Harry Potter

FILM VAULT

VOLUME 4

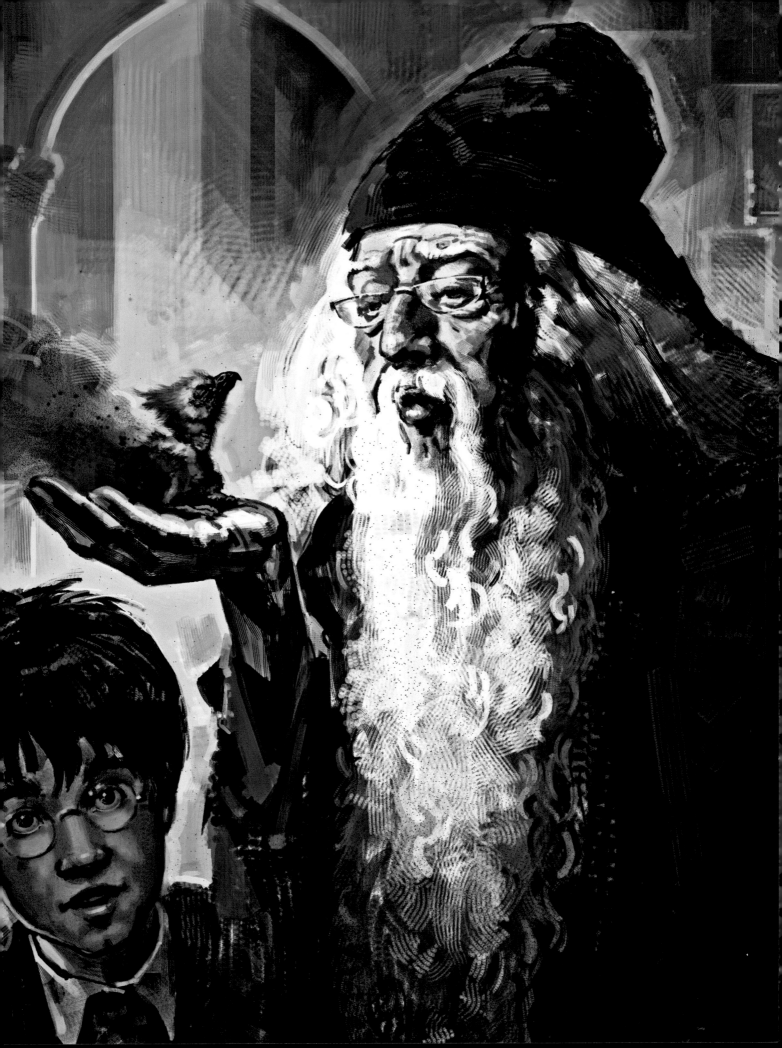

FILM VAULT

VOLUME 4

Hogwarts Students

By Jody Revenson

WIZARDING WORLD

INSIGHT EDITIONS

San Rafael, California

Introduction

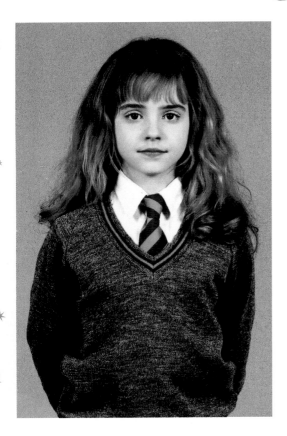

At Hogwarts School of Witchcraft and Wizardry, students make life-long friends who will provide encouragement and comfort, and maybe more important, help when you need to fight a troll, travel through time, or battle a Dark wizard. When it was announced that the Harry Potter novels would be turned into films, thousands of young people lined up to audition or sent in audition videos, hoping to be cast as Harry Potter, Ron Weasley, Hermione Granger, or any one of their many classmates.

"They all really needed to connect as friends and be relatable to kids all over the world," says director Chris Columbus. "And they had to possess that thing where the camera loves them. When you see them, you know they're stars." And so, the search began for the Hogwarts students and especially what the press called "the one in glasses," "the girl," and "the other boy."

Emma Watson went through a long audition process to become Hermione Granger, until finally she was among the last girls to try out with different combinations of actors playing Harry and Ron. "Obviously, the chemistry between the three of us and how we all looked together was incredibly important," Emma says. "[Producer] David Heyman said that I was cast pretty early on, and I wish I'd known. It would have saved me many sleepless nights."

A year before casting started for *Harry Potter and the Sorcerer's Stone*, Rupert Grint entered a Ron Weasley look-alike contest. "I won, too," he says proudly. "I had always felt a connection to Ron. When I read the books, I always said if they make the movie, I could be Ron." Rupert sent in a recording of

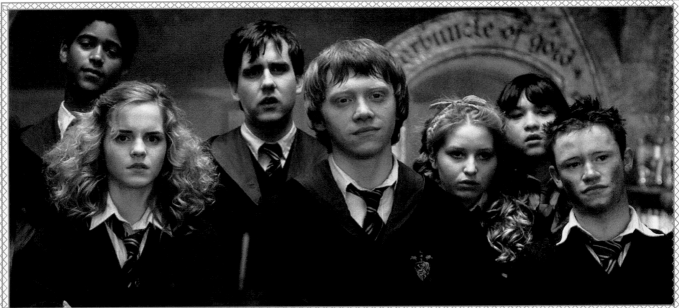

TOP: Emma Watson (Hermione Granger) poses in her Hogwarts uniform for *Harry Potter and the Sorcerer's Stone*; ABOVE: Sixth-year students respond to a Potions class challenge in *Harry Potter and the Half-Blood Prince*—(left to right) Dean Thomas (Alfred Enoch), Hermione Granger (Emma Watson), Neville Longbottom (Matthew Lewis), Ron Weasley (Rupert Grint), Lavender Brown (Jessie Cave), Leanne (Isabella Laughland), Seamus Finnigan (Devon Murray); OPPOSITE TOP: Visual development artwork by Adam Brockbank of Hermione meeting Hagrid's giant half-brother, Grawp, in *Harry Potter and the Order of the Phoenix*; OPPOSITE BOTTOM: Costume continuity reports provide information to the costume crew to ensure each outfit looks exactly the same in each shot: On the left, a list of what Dumbledore is wearing in a specific scene; on the right, instructions on the correct way to wrap the Sorting Hat when Fawkes carries it to Harry in the Chamber of Secrets.

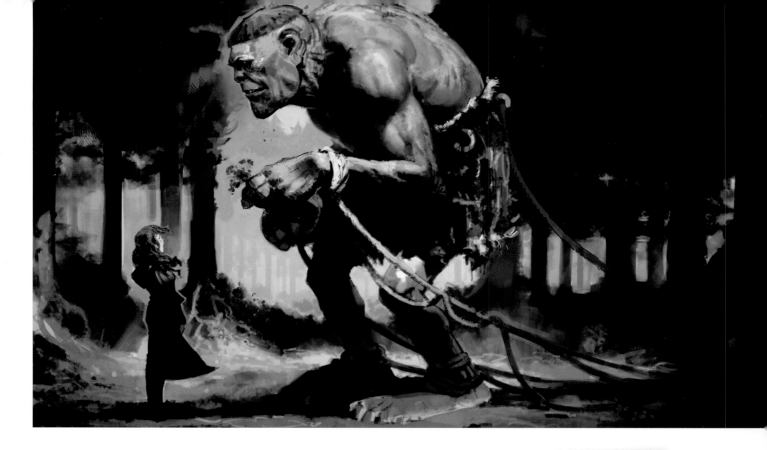

himself reciting a rap that explained just how much he wanted the part, and he got a call from the casting director.

It took a long time to find the right actor to play Harry Potter. Hundreds of actors auditioned, but it wasn't until David Heyman met Daniel Radcliffe that he knew he'd found their Harry. Daniel then auditioned for director Chris Columbus. "There was something going on behind his eyes," says Columbus. "He had the magic, the inner depth, and the darkness that no one else had. He had a sense of wisdom and intelligence that I hadn't seen in any other kid his age."

Once the actors had been cast, Hogwarts needed a distinctive uniform for its pupils. Costume designer Judianna Makovsky created robes, sweaters, and skirts for the students starting with *Sorcerer's Stone*. She called the style "scholastic wizardry," which played off the uniforms of nineteenth-century English boarding schools. *Harry Potter and the Prisoner of Azkaban* brought with it a new approach to the costumes used in the films, as the stories got darker and the kids got older. New costume designer Jany Temime took her inspiration from the street. "The wizarding world is a secret society, with their own traditions and culture, but they cannot ignore the modern world; they live parallel to it," she says. So, in addition to dressing students in robes with hoods, she dressed them in actual hoodies and other Muggle clothes.

Through the years, Daniel Radcliffe, Rupert Grint, and Emma Watson got along really well, "because we're all quite like our characters," Daniel reflects. "Rupert's very funny, Emma's very intelligent, and I'm in-between because that's, I think, how Harry is."

With the casting of "the one in glasses," "the girl," and "the other boy," and their other friends and foes, Harry Potter and his fellow students were ready to enter Hogwarts.

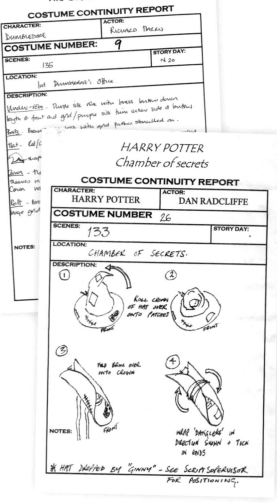

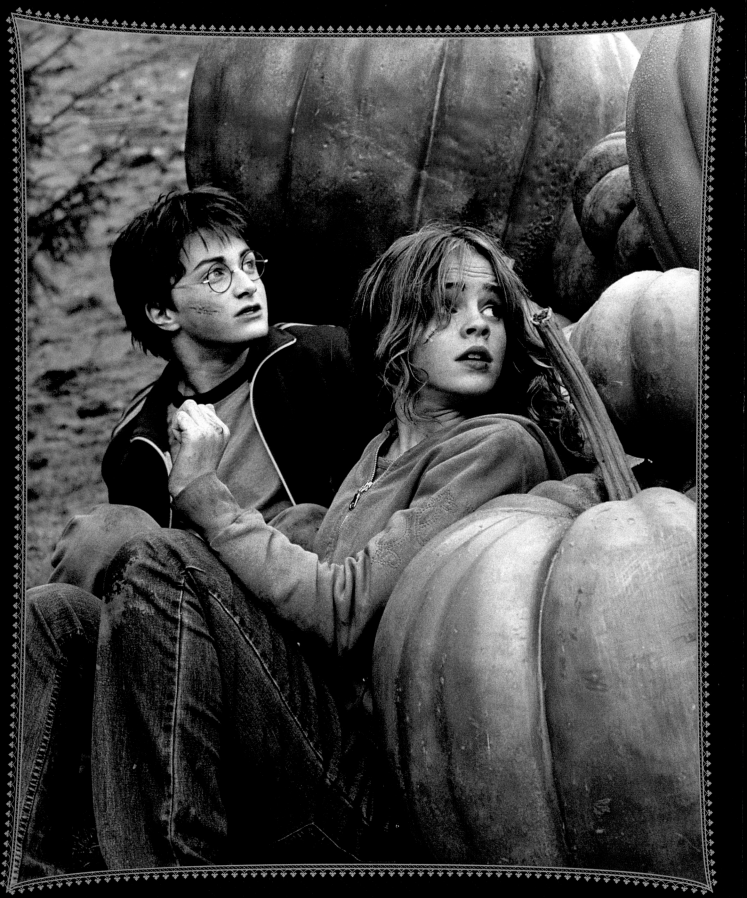

— Chapter 1 —

HOGWARTS STUDENTS

Harry Potter

Fitting in is a perceptible theme throughout the world of Harry Potter, perhaps no more plainly showcased than in the hand-me-down clothes Harry himself wears in his first appearances on-screen. Forced to live with his aunt and uncle, Harry is relegated to wearing his considerably larger cousin Dudley's castoffs, so overwhelming in size that he literally doesn't "fit in." Then Harry receives his letter from Hogwarts.

This, of course, needed to be reflected in his developing costume design. Judianna Makovsky, costume designer for *Harry Potter and the Sorcerer's Stone*, wanted to ensure that Harry's immersion into Diagon Alley and the wizarding world, coming from the middle-class Muggle environment of Privet Drive, evoked the same sense of amazement that viewers felt upon Dorothy's entrance into the Emerald City in *The Wizard of Oz*. "Harry is going on a journey to a world he is not part of it yet," says Makovsky. "I felt that for the first film you should feel Harry's awe at entering this whole new world that he could never imagine." For that purpose, Makovsky designed wizarding wear that suggested another time period recognizable to modern viewers, but still felt as if it could coexist with today's world. "But once Harry becomes part of Hogwarts," Makovsky continues, "he fits in with the world."

FIRST APPEARANCE:
Harry Potter and the Sorcerer's Stone

ADDITIONAL APPEARANCES:
Harry Potter and the Chamber of Secrets
Harry Potter and the Prisoner of Azkaban
Harry Potter and the Goblet of Fire
Harry Potter and the Order of the Phoenix
Harry Potter and the Half-Blood Prince
Harry Potter and the Deathly Hallows – Part 1
Harry Potter and the Deathly Hallows – Part 2

HOUSE:
Gryffindor

OCCUPATION:
Hogwarts Student, Gryffindor Seeker, Triwizard Tournament Champion, Chosen One

MEMBER OF:
Head of Dumbledore's Army

ADDITIONAL SKILL SET:
Parseltongue

PATRONUS:
Stag

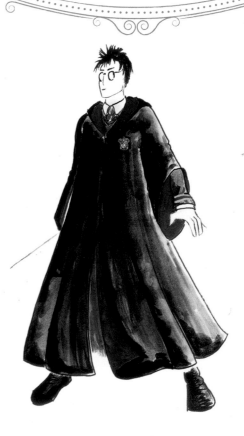

PAGE 6: Harry and Hermione wait for the right time to save Buckbeak in *Harry Potter and the Prisoner of Azkaban*; INSET: Harry holds the Golden Snitch in *Harry Potter and the Sorcerer's Stone*; ABOVE: Harry is yet to "fit in" to costume designer Judianna Makovsky's Dickensian Diagon Alley in *Sorcerer's Stone*; RIGHT: Sketch of Jany Temime's revised student robes for *Prisoner of Azkaban*. Costume illustration by Laurent Guinci; OPPOSITE: Publicity photo for *Harry Potter and the Deathly Hallows – Part 1*.

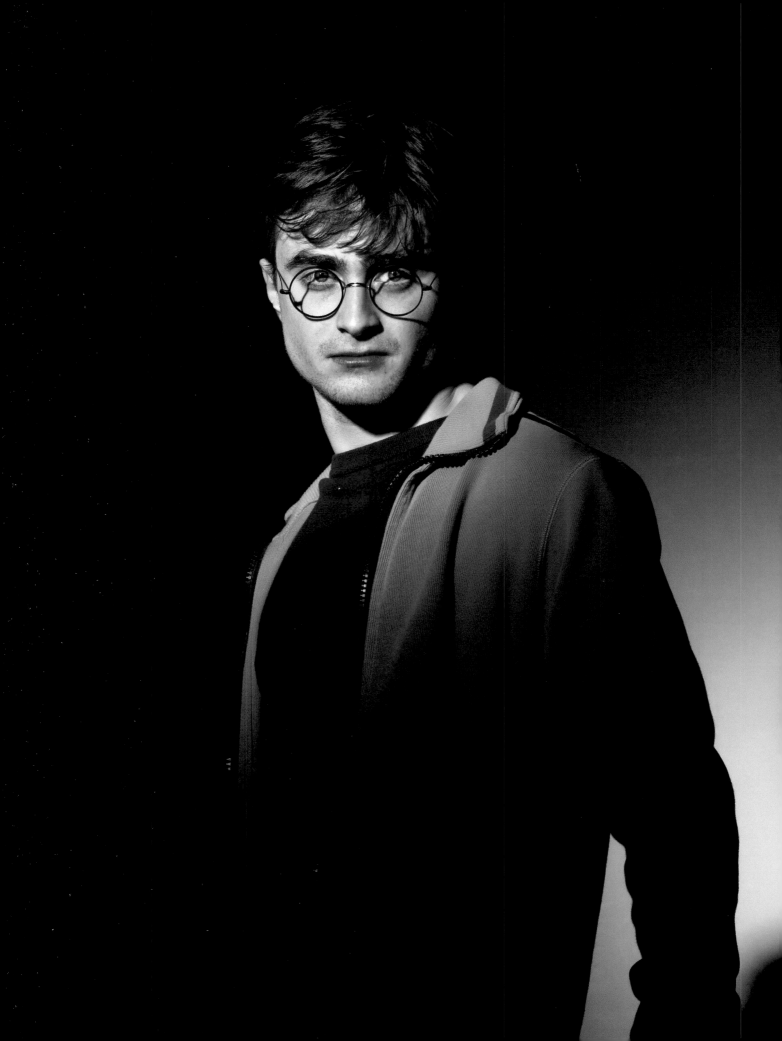

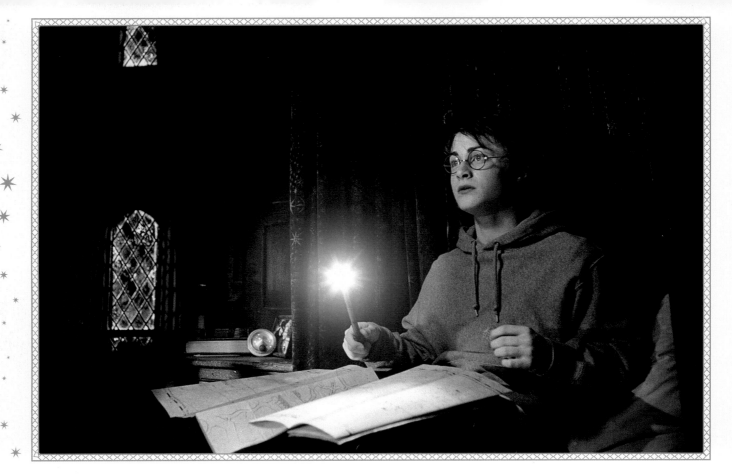

Fans should note that the filmmakers made and tested out a version of Harry's outfit from the cover of the American novel. "Every country has a different illustration on the cover," says Makovsky, "but we made the one with the red-and-white rugby shirt, jeans, and Converse. Then we put him in the wizard gown and it just didn't work. Everybody wanted it, and every once in a while we'd put it on Harry, but Chris [Columbus] would say, no, it just doesn't work." Makovsky believes that the choice of uniformity for the wizarding school robes to establish the school's atmosphere worked better than the more casual outfit, "though it might have worked in the third movie."

When costume designer Jany Temime came aboard for *Harry Potter and the Prisoner of Azkaban*, director Alfonso Cuarón had already made the decision that the growing kids should begin wearing more contemporary clothes along with their school robes. This allowed Temime to develop individual color schemes to be a visual complement for each character. Temime thought of Harry Potter as "an outlaw. He's a kid who's not sure where he belongs. I thought, this is a lonely boy." The designer dressed him in very soft, muted colors: gray-blues, navies, and monochromatic checks. "You know when you feel you don't belong, when you don't feel good in your skin, you don't like to wear bright colors." One exception was the use of Gryffindor scarlet, which Harry would often wear during battle scenes with Voldemort or his Dark forces.

Several cosmetic adjustments were needed to bring the character from the page to the screen. In the books, Harry's eyes are green. Blue-eyed Daniel Radcliffe was fitted with contact lenses, but as happens in a small percentage of the population, his eyes reacted badly, becoming irritated and swollen. (This is evident in the last scene of *Harry Potter and the Sorcerer's Stone*, the only time Radcliffe appears on-screen with green,

TOP: Harry Potter wears a hooded sweatshirt in *Harry Potter and the Prisoner of Azkaban*; BOTTOM LEFT: One of the thousands of pairs of Harry's glasses; BELOW: Interchangeable separates became the fashion for Hogwarts uniforms starting with *Prisoner of Azkaban*. Illustration by Laurent Guinci; OPPOSITE TOP TO BOTTOM: Continuity shots for *Harry Potter and the Sorcerer's Stone*.

SC. 13 →
HARRY

SC. 12
HARRY

GAP FLAT FRONT SLIM FIT ·
T SHIRT
SHIRT
34 × 30

INVISIBILITY CLOAK

Several versions of Harry Potter's Invisibility Cloak, given to him for Christmas by Albus Dumbledore in Harry Potter and the Sorcerer's Stone, were constructed by the costume department out of a thick velvet fabric that was dyed and then imprinted with astrological and Celtic symbols. There was a fully realized and lined cloak that Daniel Radcliffe (Harry Potter) would use to hold or to wear over a suit made of green-screen material. The version used to make him invisible was lined on its interior with green-screen material. Radcliffe would flip the cloak so that the green side faced up when he placed it over himself.

Ron and Harry learn about the Invisibility Cloak. In postproduction, the green-screen material was removed from inside of the cloak, so on-screen Harry's body appeared invisible.

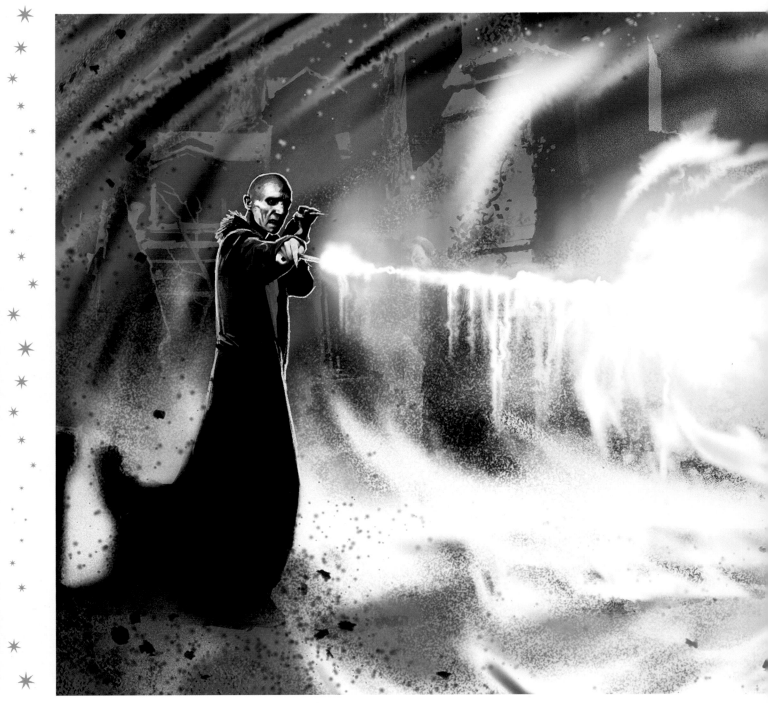

Harry Potter and Lord Voldemort duel in Little Hangleton graveyard in concept art by Adam Brockbank for *Harry Potter and the Goblet of Fire*.

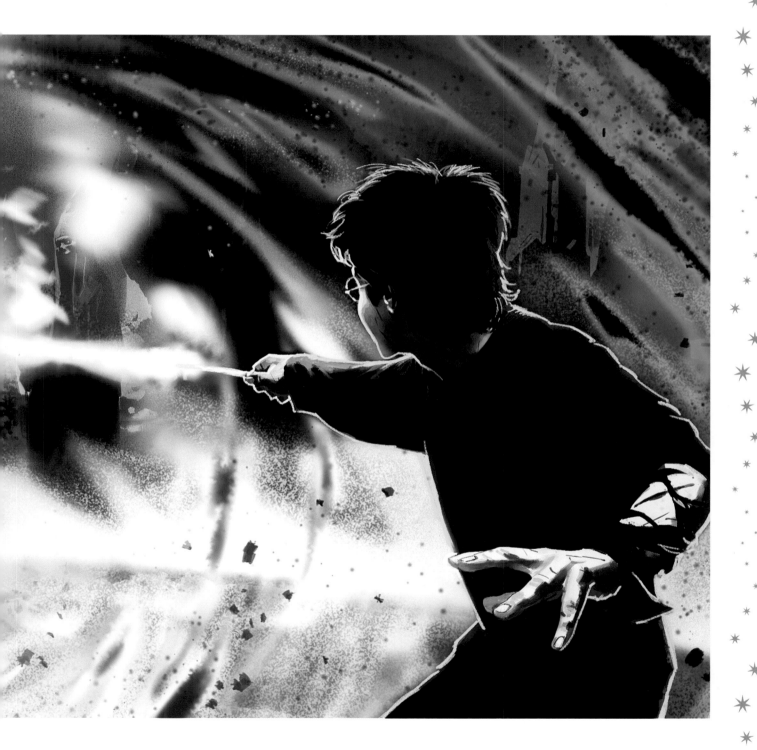

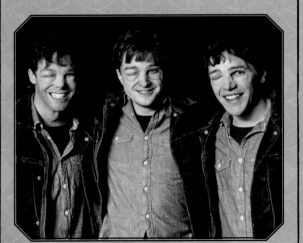

STINGING JINX

When Harry, Ron, and Hermione are captured by Snatchers in Harry Potter and the Deathly Hallows – Part 1, Hermione performs a Stinging Jinx so that Harry won't be recognizable. Creature effects designer Nick Dudman created three progressive stages of makeup, as the jinx eventually wears off over the course of several scenes. In its most intense phase, Daniel Radcliffe had several prosthetics applied to his face, including one with a swollen fake eye. Dudman strove to ensure that even though the audience would know who it was, the disguise would be convincing enough to believe that Voldemort's emissaries wouldn't recognize Harry. Amanda Knight recalls that although it was difficult for the actors and crew to see Radcliffe so disfigured, it was more difficult for the actor—it took four hours to apply the makeup, and Radcliffe wasn't allowed to eat anything until the makeup was removed.

TOP: The result of Hermione's Stinging Jinx; ABOVE: Daniel Radcliffe, double Ryan Newbery (left), and stunt double Marc Mailley (right) in Stinging Jinx makeup.

though red-infused, eyes.) The decision was quickly made to allow Harry's eyes to be blue in the film. Radcliffe was also equipped with the iconic glasses, made out of a nickel alloy. Shortly after filming began, the actor developed blemishes, not completely out of line for an adolescent, but Radcliffe's father, Alan, noticed that the spots occurred in a perfect circle around each eye that matched where the glasses sat on his son's face. It was discovered that Radcliffe had an allergy to nickel, and so the frames were swapped out for a safer material. The glasses rarely had lenses in them, in order to avoid reflections of the lights or cameras. After the final film, Radcliffe chose to take his first and last pairs of glasses as souvenirs.

Harry's scar was stenciled daily onto his forehead via a fixed template, and then built up with prosthetic scar material. Chief makeup artist Amanda Knight, who worked on all eight Harry Potter films, recalls that in his younger years, "He used to pick off his scar when he was in class. We had a school on site, where the children would be taught, and he'd come back to the set with it hanging off." Knight adjusted Harry's makeup very subtly according to the circumstances of the scene. "When Voldemort was near Harry, we'd make him slightly paler," Knight explains. "At the same time, we'd make Harry's scar stronger, redder, and more angry looking when Voldemort was close. It shouldn't jump out at you from the screen, but I think in its way, it helped the actors and added to the feel of the scene." It's estimated that Harry Potter's scar was applied more than 5,000 times: 2,000 times on Daniel Radcliffe, and 3,800 times on his stunt doubles.

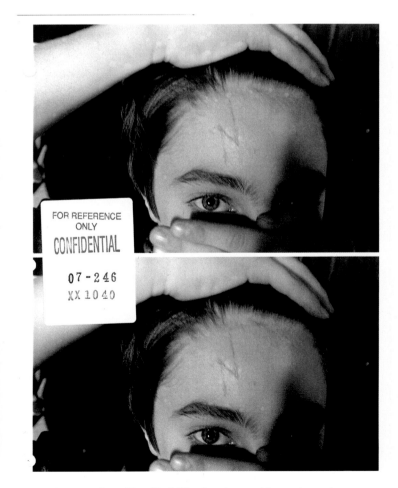

ABOVE: Continuity shots of Daniel Radcliffe referencing one of the two thousand or more iterations of Harry Potter's scar; OPPOSITE TOP: Harry encounters Dementors in *Harry Potter and the Order of the Phoenix.*

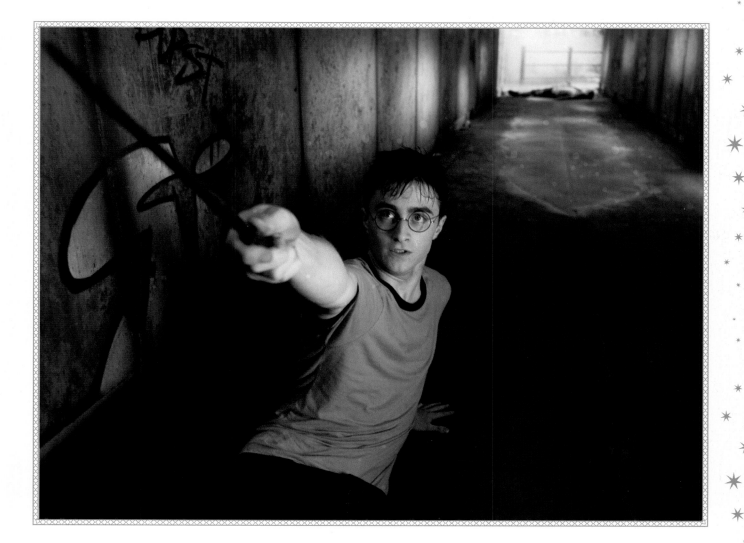

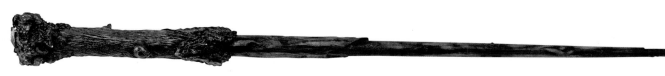

HARRY'S WAND

J.K. Rowling's initial concept for the wizard's wands was that they were "just like an old stick," says draftsman Hattie Storey, so in the first two films, the wands were mostly simple, straight, and unembellished. For *Harry Potter and the Prisoner of Azkaban*, director Alfonso Cuarón wanted to reassess the look of the wands, making them more personal to the wizard, and had several types of unique wands made up for the cast to choose from. Daniel Radcliffe chose a wand with a decidedly organic look to it. Harry's wand was crafted from Indian rosewood, which the prop makers selected for its beautiful deep red color. The "bark" is a sculpted interpretation, but the hewing was done on a real piece of wood. "The top was cast from a tree burr," explains prop modeler Pierre Bohanna. "It's a naturally occurring piece of wood that grows at the bottom of the tree. This gives it a lot more character in, essentially, a very small piece of wood." Radcliffe went through almost seventy wands while filming the Harry Potter series.

"I'm just Harry. Just Harry."

HARRY POTTER,
Harry Potter and the Sorcerer's Stone

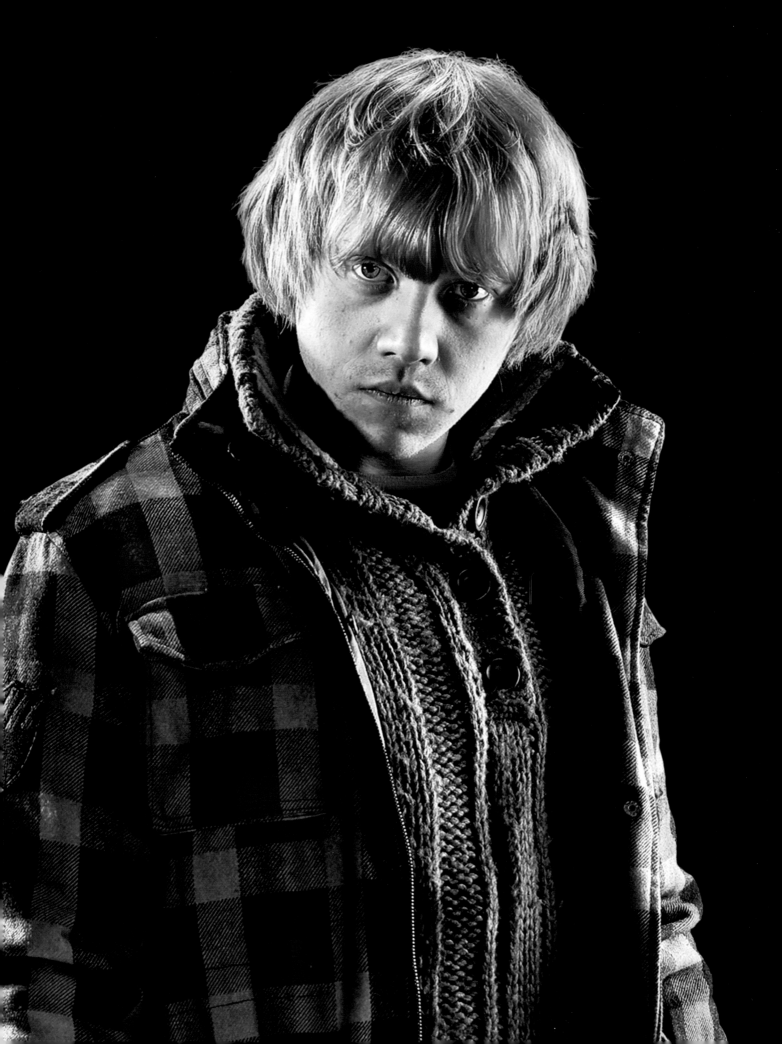

Ron Weasley

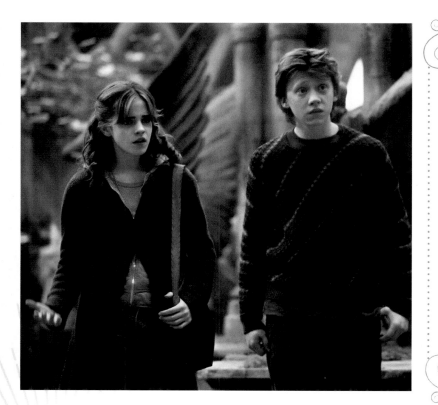

FIRST APPEARANCE:
Harry Potter and the Sorcerer's Stone

ADDITIONAL APPEARANCES:
Harry Potter and the Chamber of Secrets
Harry Potter and the Prisoner of Azkaban
Harry Potter and the Goblet of Fire
Harry Potter and the Order of the Phoenix
Harry Potter and the Half-Blood Prince
Harry Potter and the Deathly Hallows – Part 1
Harry Potter and the Deathly Hallows – Part 2

HOUSE:
Gryffindor

OCCUPATION:
Hogwarts Student, Gryffindor Keeper (sixth year)

MEMBER OF:
Dumbledore's Army

PATRONUS:
Jack Russell terrier

Actor Rupert Grint felt an affinity to Ron Weasley from his first reading of the Harry Potter novels. "We had a lot of little things in common. Obviously, I'm a ginger," Grint says with a laugh. "We both come from large families. I felt my family was quite similar to the Weasleys, really." After a series of auditions, Grint landed the part, but can't remember his reaction when he got the news. "It's not like I blacked out or anything. I guess it's weird but the only thing I can remember is an intense happiness."

Judianna Makovsky's approach to the character of Ron helped define the look of the Weasley family. "Because his family isn't as rich as other wizarding families," explains Makovsky, "and they're a bit like outcasts because of that, I tried to make his clothes a little stranger than everybody else's. His mother likes to—and really needs to—make all of his clothing. He wore a lot of knitted sweaters that looked a little off, that weren't perfect for him." One clothing tradition became the "initial" sweater that Molly Weasley would give as a present every Christmas.

INSET: Ron Weasley dressed in a special Molly Weasley creation—the ubiquitous initialed Christmas sweater in *Harry Potter and the Sorcerer's Stone*; OPPOSITE: Rupert Grint in a publicity photo for *Harry Potter and the Deathly Hallows – Part 1*; TOP: Hermione and Ron on their way to Hogsmeade in *Harry Potter and the Prisoner of Azkaban*. Ron's sweater is more classic Molly Weasley; RIGHT: Sketch of Ron's unique dress robes for the Yule Ball in *Harry Potter and the Goblet of Fire*. Costume design by Jany Temime, illustration by Mauricio Carneiro.

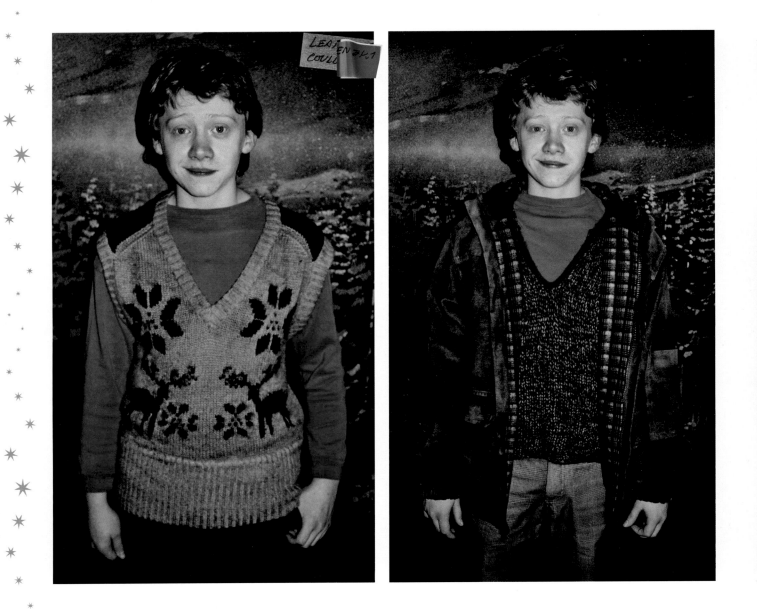

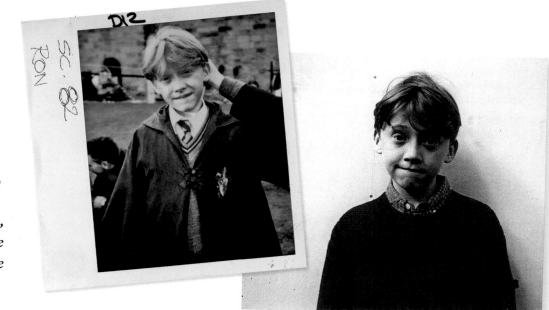

"*I'm Ron, by the way. Ron Weasley.*"

RON WEASLEY,
*Harry Potter and the
Sorcerer's Stone*

Jany Temime counts Ron as possibly her favorite character to dress. "We would laugh every year when we put his costumes together. We would think, that's so awful. You must always wear what Mom gives you," she continues. "But his mom has bad taste, so Ron is very unlucky. His mom has *really bad* taste. But I think he carries it off. Rupert wore everything with one hundred percent sincerity, and he wore it beautifully. He's so likeable, we don't worry about liking what he wears. When he got a bit older, she stopped making them, thank goodness. But he could never really get rid of the style in him."

Temime was resolute about her color palette for Ron and his family of gingers. "It was always orange-y, brownish, greenish. That was the color of the Weasleys." In addition to the colors, Temime often used plaids, checks, and stripes to give the clothes a sense of texture, and sometimes combined all of these in the same outfit.

OPPOSITE TOP: Costume possibilities reflect the Weasley color palette in *Harry Potter and the Prisoner of Azkaban*; OPPOSITE BOTTOM: Continuity shots for *Harry Potter and the Sorcerer's Stone*; LEFT: Rupert Grint on the set of *Harry Potter and the Half-Blood Prince*; BELOW: Ron and his father, Arthur (Mark Williams), showcase Temime's penchant for using checks and patterns to create textures, *Harry Potter and the Deathly Hallows – Part 1*.

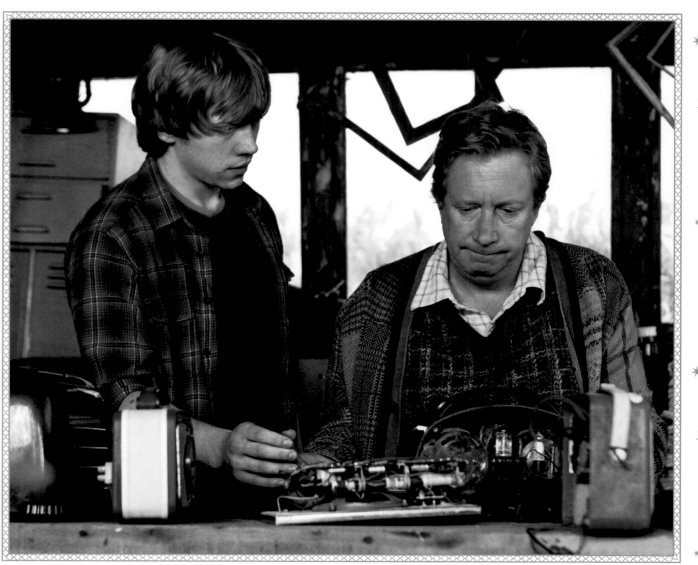

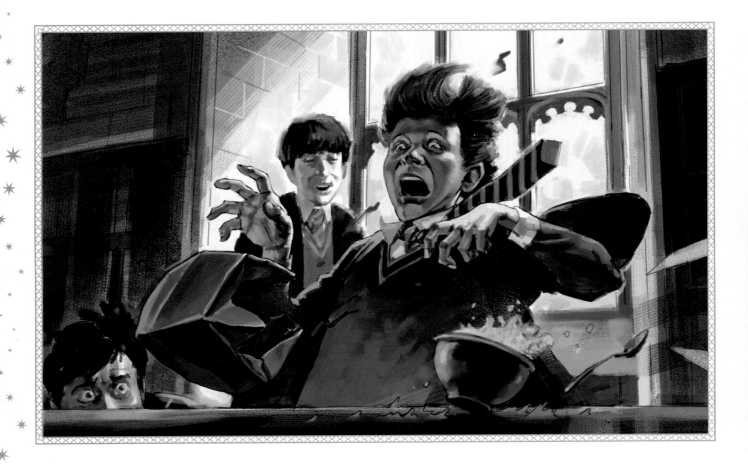

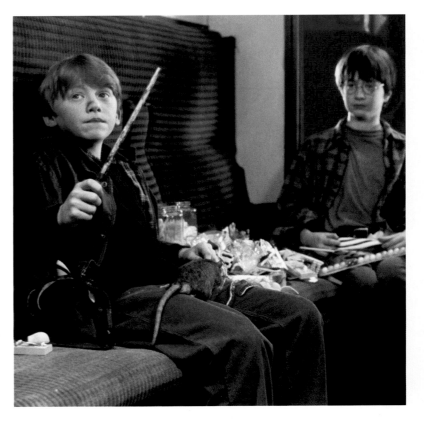

RON'S WAND

Ron Weasley's first wand, a simple baton style, was broken by the Whomping Willow in *Harry Potter and the Chamber of Secrets*. His second wand echoes the Weasley aesthetic with a rustic interpretation. "It's slightly similar to Harry's," says Pierre Bohanna, "but not quite so refined. It's a bit more like a root that's been whittled quickly." The wands used by the actors were molded from wood, but created in resin. "The trouble is," explains Bohanna, "actual wood wands would be dangerous to use. If they fell, they'd split and shatter. And, wood, by its nature, would be affected by humidity, heat, and cold, and it could bend, buckle, or break, so it's not a practical material to use day to day."

TOP: Ron Weasley's reaction to his mother's Howler as visualized by Adam Brockbank for *Harry Potter and the Chamber of Secrets*; RIGHT: Ron and Harry on the Hogwarts Express before changing into their robes in *Harry Potter and the Sorcerer's Stone*; OPPOSITE LEFT: Rupert Grint portrays the new Gryffindor Keeper in a publicity photo for *Harry Potter and the Half-Blood Prince*.

THE BIGGEST BRUISER

In the early days of filming the Harry Potter films, Daniel Radcliffe and Rupert Grint often competed to see who could have the biggest cut or bruise applied by the makeup team, recalls Amanda Knight, "which seemed like a good idea at the time to them. But as scenes often took weeks or months to film, they'd begin to wish they'd opted for a smaller makeup job!"

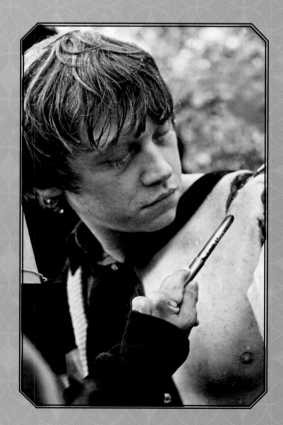

TOP: A scratched and bruised Harry Potter after a Quidditch match in *Harry Potter and the Prisoner of Azkaban*; ABOVE: Rupert Grint has his splinched shoulder touched up in *Harry Potter and the Deathly Hallows – Part 1*.

Hermione Granger

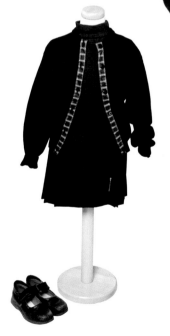

When I was being interviewed during early films," says actress Emma Watson, who plays Hermione Granger, "I would say I'm not like her at all, and try to convince everyone that I wasn't. I was absolutely adamant about that. But at school, I was very academic and very insecure and a bit of a tomboy. I basically *was* her, to be fair! And I think that helped me 'get' her. I believe I'm a bit more sporty than she is, but I've come to accept our similarities."

Judianna Makovsky's take for Hermione Granger's wardrobe referenced the idea of classic British clothing for the few times she is not wearing her Hogwarts robes. "We looked for pleated skirts, knee socks, lovely handmade Fair Isle sweaters," recalls Makovsky, "harking back to the thirties and forties British boarding school. I think this look seemed most appropriate for her, especially as she seemed so concerned about fitting in."

In the books, Hermione is noted for having buck teeth, and so the makeup department created a set of false teeth for her to wear in *Harry Potter and the Sorcerer's Stone*. "They looked a little silly and they affected Emma's speech but we decided to try them on the first day of shooting," recalls director Chris

FIRST APPEARANCE:
Harry Potter and the Sorcerer's Stone

ADDITIONAL APPEARANCES:
Harry Potter and the Chamber of Secrets
Harry Potter and the Prisoner of Azkaban
Harry Potter and the Goblet of Fire
Harry Potter and the Order of the Phoenix
Harry Potter and the Half-Blood Prince
Harry Potter and the Deathly Hallows – Part 1
Harry Potter and the Deathly Hallows – Part 2

HOUSE:
Gryffindor

OCCUPATION:
Hogwarts Student

MEMBER OF:
Dumbledore's Army

PATRONUS:
Otter

INSET: Emma Watson as Hermione Granger; ABOVE: Hermione's costume for *Harry Potter and the Chamber of Secrets*; RIGHT: The consummate student—or, as Professor Snape calls her, "the insufferable know-it-all"—in a publicity photo for *Harry Potter and the Sorcerer's Stone*; OPPOSITE: A publicity photo for *Harry Potter and the Half-Blood Prince*.

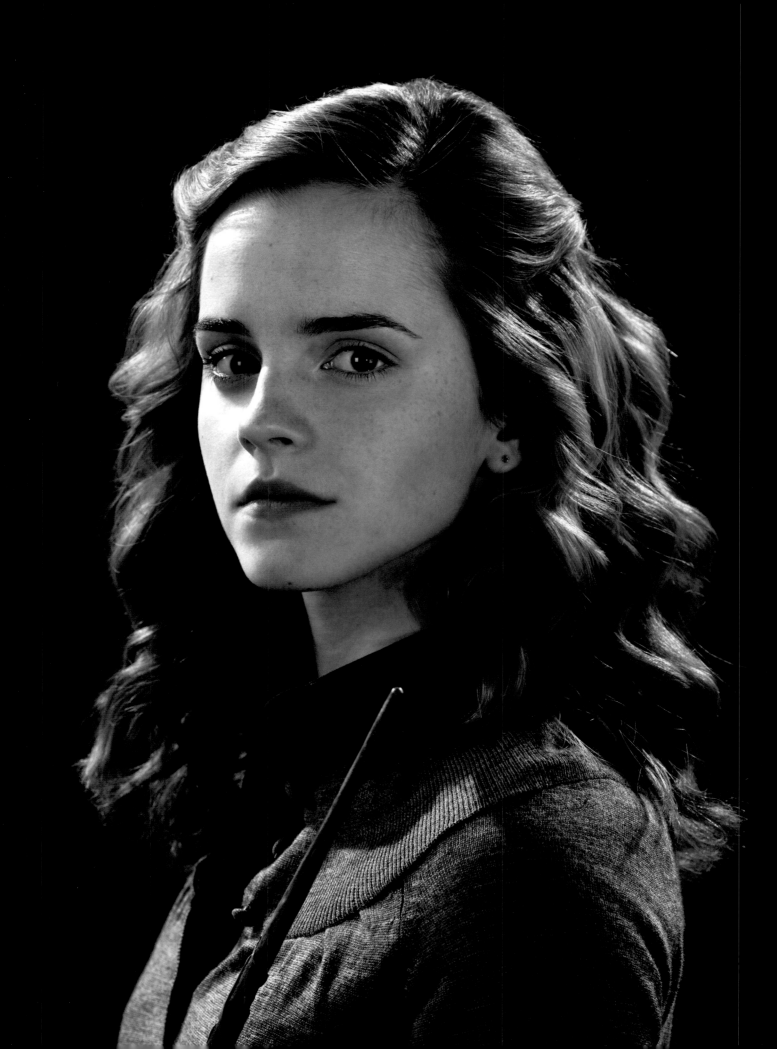

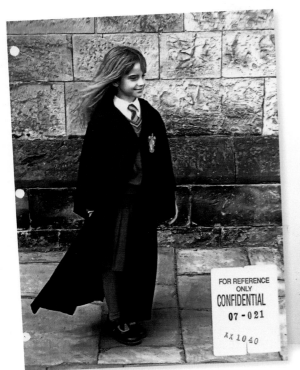

"I'm going to bed before either of you come up with another clever idea to get us killed, or worse, expelled."

H E R M I O N E G R A N G E R ,
Harry Potter and the Sorcerer's Stone

Columbus. After the day's rushes were viewed, it was immediately decided to scrap that idea. Sharp viewers can see the only use of this attempt in the last scene of *Harry Potter and the Sorcerer's Stone*, as the three children board the Hogwarts Express.

Director Alfonso Cuarón's approach—that the growing kids should express themselves through more contemporary clothing—was very much appreciated by Watson. "Thank goodness we didn't have to wear the uniforms all the time," she admits. "I was out of those itchy sweaters! I'm in jeans. Even the hair has been toned down a bit, and a little shorter. But I think this makes it much more contemporary, and shows that we're becoming teenagers." Still, Jany Temime always believed that Hermione was much more concerned about her studies than her clothes. "I dressed Hermione as a girl who felt her best asset was her brain, and wasn't worried about making an effort with her clothes," she says. "She's very busy with her studies and very down-to-earth in what she wears. She may be dressed very practically, but always looks lovely because Emma Watson is a beautiful girl." Temime chose a palette of pinks and grays for the simple, practical outfits Hermione wore. Through the course of the Harry Potter films, Temime recognized that the actress had not only a great fashion sense herself, but also knew what was good for her character. She realized at a certain point that Watson was putting the look of her part before her own personal tastes. "She would say, 'Of course it's not my taste, but Hermione would wear that, you know.'"

TOP: Early behind-the-scenes shots of Emma Watson as Hermione Granger in *Harry Potter and the Sorcerer's Stone*; LEFT: Sketches of the girls' uniforms by Mauricio Caneiro; OPPOSITE: Adam Brockbank's artwork of Hermione after she takes the Polyjuice Potion in *Harry Potter and the Chamber of Secrets*.

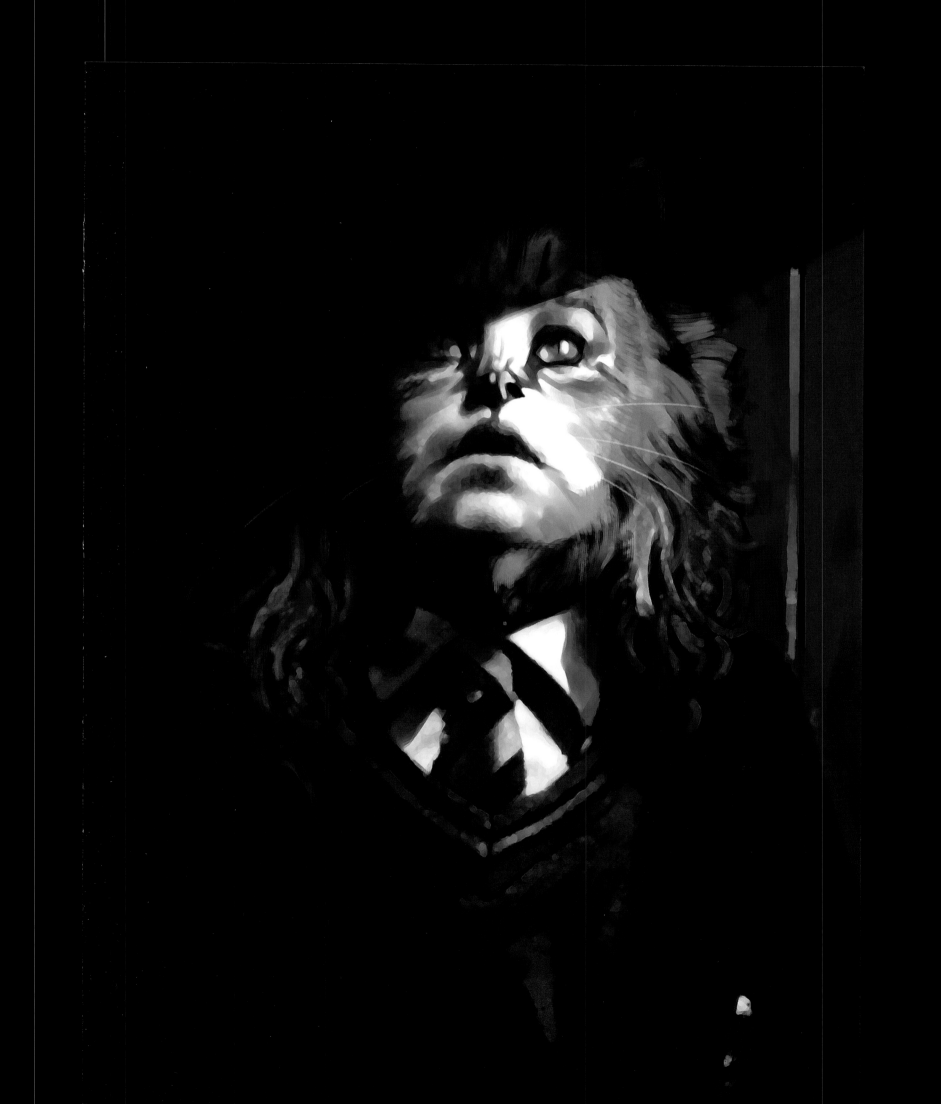

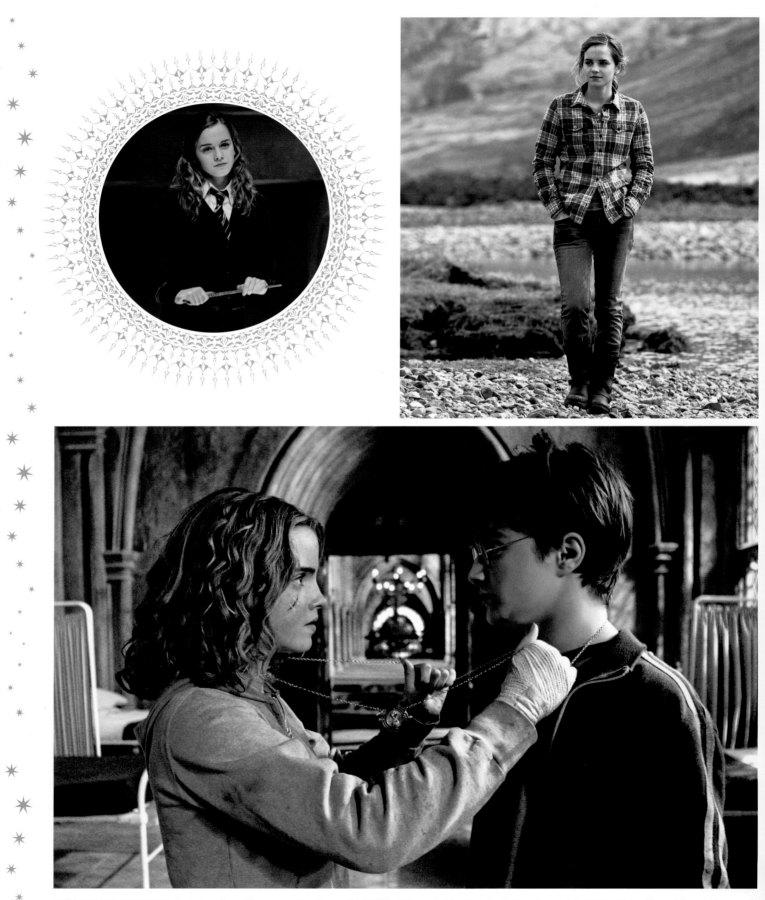

TOP LEFT AND RIGHT: Whether in her robes at Hogwarts in *Harry Potter and the Half-Blood Prince* or in Muggle clothes in *Harry Potter and the Half-Blood Prince*, Emma Watson had an intuitive sense of what her character would wear and how she would wear it; ABOVE: Hermione places the Time-Turner around Harry's neck in *Harry Potter and the Prisoner of Azkaban*. OPPOSITE LEFT AND RIGHT: Dressed up for the Yule Ball in *Harry Potter and the Goblet of Fire*, and for the Weasley wedding in *Deathly Hallows — Part 1*.

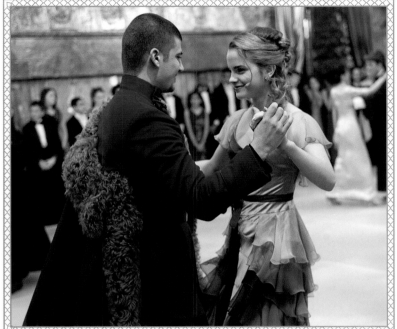

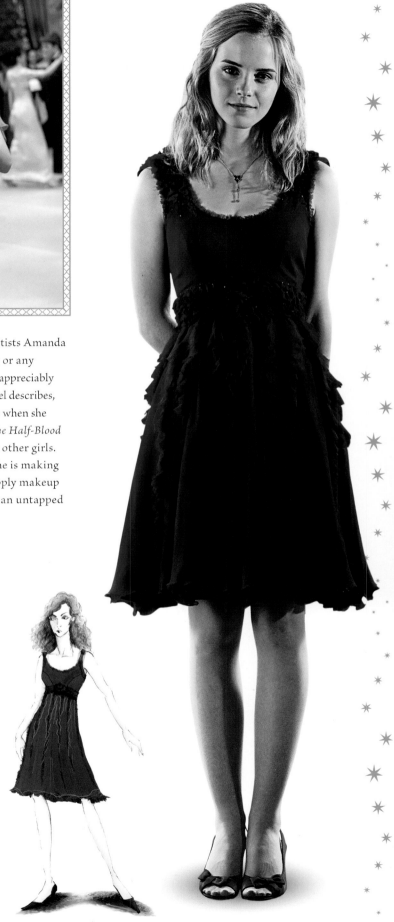

Prior to *Harry Potter and the Goblet of Fire*, hair and makeup artists Amanda Knight and Eithne Fennel were strict about not putting lip color or any other noticeable makeup on her, as her character needed to appear appreciably different for the Yule Ball. Until that point, Hermione had, as Fennel describes, "geeky" hair. And, "Hermione only became interested in her clothes when she became interested in Ron," Temime laughs. In *Harry Potter and the Half-Blood Prince*, "Hermione sees that Ron is getting lots of attention from other girls. So I think she tries harder to be more feminine. Not frilly, but she is making more of an effort." "I don't think Hermione ever knew how to apply makeup or do her hair particularly well," says Watson. "That was always an untapped universe to her."

HERMIONE'S WAND

Hermione Granger's wand was hand carved from a type of wood called "London plain," similar to limewood. It's a hardwood so it allows fine details to be carved into it. The wand was gently stained to highlight the ivy-like growth that twists all the way up to its tip. Emma Watson particularly enjoyed the wand battles. "The choreography doesn't look like anything else," she said about the Ministry battle in *Harry Potter and the Order of the Phoenix*. "It's like everything rolled into one: sword-fighting, karate, dances moves, even a bit of *The Matrix*. Putting all these together makes for something that's a completely original art form, very elegant and poised." Watson felt the scene was the first time "you really become aware and impressed by what wizards are capable of doing."

NEVILLE LONGBOTTOM

FIRST APPEARANCE:
Harry Potter and the Sorcerer's Stone

ADDITIONAL APPEARANCES:
Harry Potter and the Chamber of Secrets
Harry Potter and the Prisoner of Azkaban
Harry Potter and the Goblet of Fire
Harry Potter and the Order of the Phoenix
Harry Potter and the Half-Blood Prince
Harry Potter and the Deathly Hallows – Part 1
Harry Potter and the Deathly Hallows – Part 2

HOUSE:
Gryffindor

OCCUPATION:
Hogwarts Student

MEMBER OF:
Dumbledore's Army

"Costumes and makeup are of the utmost importance," says actor Matthew Lewis, who plays Neville Longbottom. "When you're an actor, it helps to get you into the role. When you look in the mirror and you don't see yourself, when you see the character, it really helps you to focus. I appreciate all that's been done in terms of getting me into the right frame of mind."

Neville Longbottom is not only gawky and insecure, he is pudgy and bucktoothed, with ears that come forward like Dumbo's. "For most of the films, I've worn a piece of molded plastic that makes my ears stick out. I wear false teeth that are crooked. And I wear a fat suit, all of which I think I should mention at the start of every interview I give." One cast member was completely unaware of what Lewis did to transform into his character. When Jessie Cave, who plays Lavender Brown, came back for Harry Potter and the Deathly Hallows – Part 2, she made a comment to a member of the costume department about how impressed she was at Matthew Lewis's weight loss. The costumer informed her that Lewis wore a fat suit for the part. "I think she's been apologizing to me every time she sees me now," Lewis says with a laugh. "She told me that she thought that my weight just fluctuated up and down!"

Lewis stopped wearing the false teeth and protruding ears in Harry Potter and the Order of the Phoenix, and lost the fat suit for Harry Potter and the Deathly Hallows – Part 1 and Part 2. "I was lucky that I could take everything off at the end

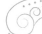

INSET: Matthew Lewis as Neville Longbottom; TOP: Neville is seen onto the Hogwarts Express by his grandmother (Leila Hoffman) in Harry Potter and the Sorcerer's Stone; RIGHT: Neville in Sorcerer's Stone with buck teeth and padded waist; OPPOSITE: A publicity photo from Harry Potter and the Deathly Hallows – Part 2.

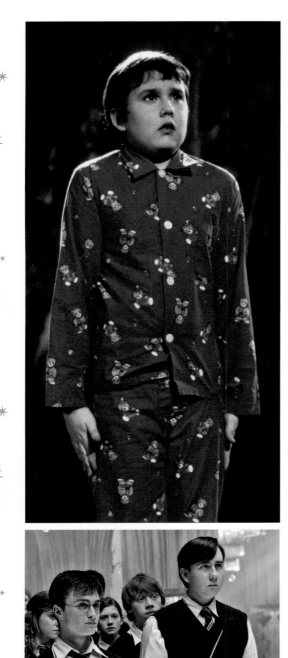

of the day," observes Lewis, "but in *Deathly Hallows – Part 2*, Neville's slimmed down. We're trying to suggest he's living underground at Hogwarts, and he's been this resistance leader. So he's not had time to eat, and he's been stressing out." There was another prosthetic that included a headpiece Lewis wore during the battle for Hogwarts, as he's received a wound. "The first week, it was really enjoyable. I thought, 'This is fun! This is great.' Then it gets pretty boring. The novelty definitely wears off."

Lewis observed a great transformation not only in his character, but in himself. "When I started, I wasn't that far detached from Neville. I was quite shy and definitely not the top of my class and I didn't want to speak up in a crowded room, but as he started growing confidence in his own abilities, so did I. Of course, we bring our own life experiences into a role, but I think now as much as there is Matt Lewis in Neville, I'm glad to think some Neville has found its way into Matt Lewis."

NEVILLE'S WAND

Neville Longbottom's wand is defined by a spiral on its dark wood handle that creates a three-part twist. Matthew Lewis (Neville) remembers pretending to play a Harry Potter game after he read *Harry Potter and the Sorcerer's Stone*. "A friend and I put on bathrobes to be our school robes," he explains, "and then we went outside, got some twigs to be our wands, and fired spells at each other all day." Draftsman Hattie Storey would agree with his choice of the natural material. "I always thought the more successful wands were those that looked like they were half-whittled out of a bit of root. They look quite magical, I think, and mysterious."

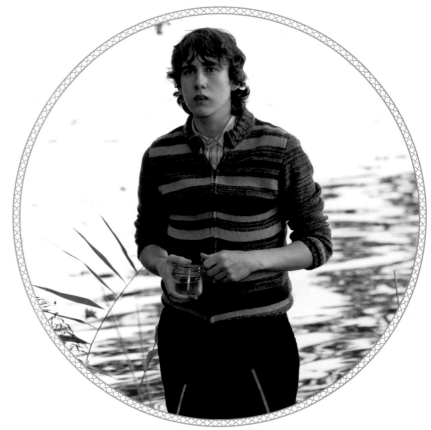

TOP: A pajama-clad Neville is rendered immobile by *Petrificus Totalus* in *Harry Potter and the Sorcerer's Stone*; ABOVE: Practicing the Disarming Charm in *Harry Potter and the Order of the Phoenix*; RIGHT: Helping Harry by providing Gillyweed for the second task in *Harry Potter and the Goblet of Fire*; OPPOSITE TOP: Visual development artist Andrew Williamson paints a lyrical picture of Neville practicing the waltz atop a Hogwarts roof in *Goblet of Fire*; OPPOSITE BOTTOM: Neville brings Hermione, Ron, and Harry to the Room of Requirement in *Harry Potter and the Deathly Hallows – Part 2*.

"Why is it always me?"

NEVILLE LONGBOTTOM,
Harry Potter and the Chamber of Secrets

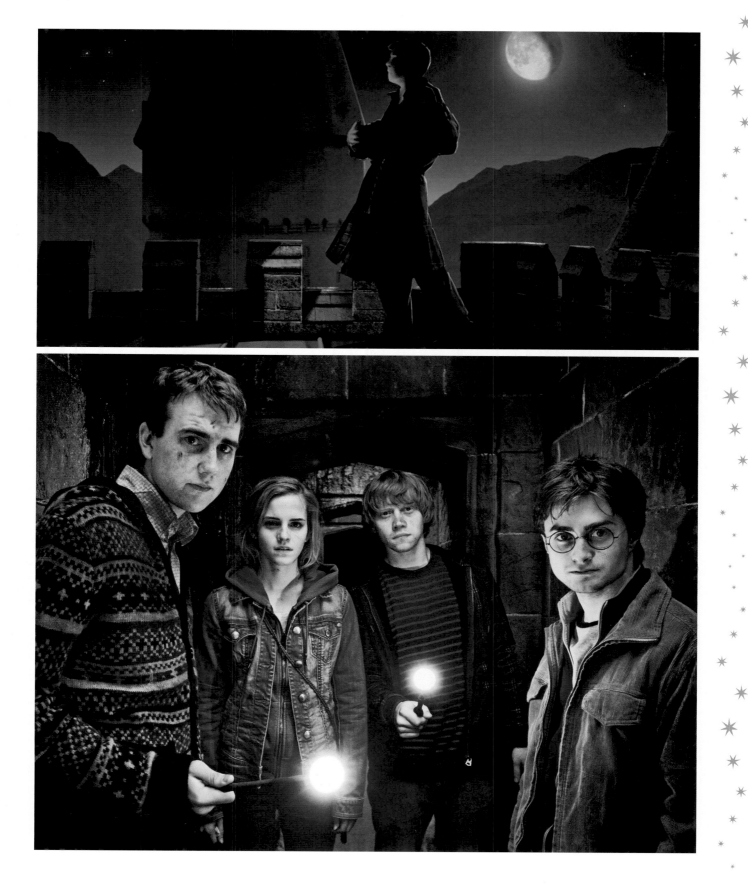

Fred & George Weasley

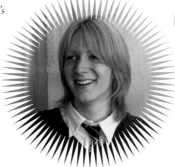

James and Oliver Phelps, who play Fred and George Weasley, respectively, were fans of the Harry Potter books from the start, but admit that when their mother told them about an open casting call for *Harry Potter and the Sorcerer's Stone*, they were more interested in having a day off from school. "We said, 'Okay, yeah, all right, if we *have* to,'" recalls James. At the audition, they realized that they were the only twins not wearing identical clothing, so ran to the nearest shop to find matching shirts. Then none of their friends believed them when they were eventually cast as the Weasley twins until they turned up at school one day with ginger-colored hair. The final hitch was when they showed up for the first script read-through. "When we got there," recalls Oliver, "we went to one of the associate directors to ask who was playing who?" "We had gotten two scripts," James continues, "but no one had told us who was Fred and who was George! Finally, someone from casting told us who was who, but we were never sure if it was planned or just a quick decision."

When not in Hogwarts robes, Fred and George were dressed identically in *Harry Potter and the Sorcerer's Stone* and *Harry Potter and the Chamber of Secrets*, holding up their end of the Weasley homemade style. Jany Temime continued the tradition until *Harry Potter and the Order of the Phoenix*, when it's clear that the twins are establishing their own identities as they begin the process of becoming entrepreneurs. In addition to wearing their school clothing differently,

FIRST APPEARANCE:
Harry Potter and the Sorcerer's Stone

ADDITIONAL APPEARANCES:
Harry Potter and the Chamber of Secrets
Harry Potter and the Prisoner of Azkaban
Harry Potter and the Goblet of Fire
Harry Potter and the Order of the Phoenix
Harry Potter and the Half-Blood Prince
Harry Potter and the Deathly Hallows – Part 1
Harry Potter and the Deathly Hallows – Part 2

HOUSE:
Gryffindor

OCCUPATION:
Hogwarts Students, Gryffindor Beaters,
owners of Weasleys' Wizard Wheezes

MEMBERS OF:
Dumbledore's Army

INSETS: The Weasley twins: George (Oliver Phelps, top) and Fred (James Phelps, center); ABOVE: Fred and George follow their older brother Percy (Christopher Rankin) onto Platform 9 ¾ in *Harry Potter and the Sorcerer's Stone*; RIGHT: Jany Temime felt the twins "branded" their look in *Harry Potter and the Half-Blood Prince*, illustration by Mauricio Carneiro; OPPOSITE: A publicity shot for *Half-Blood Prince*.

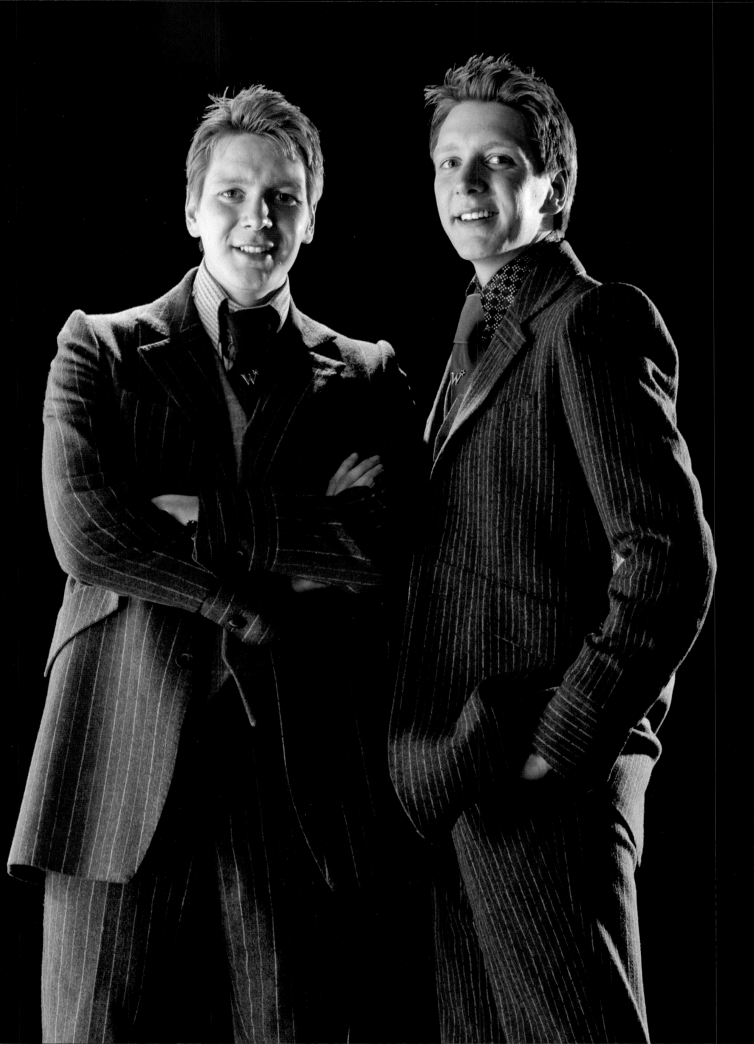

"Wow, we're identical!"
Harry Potter and the Deathly Hallows – Part 1

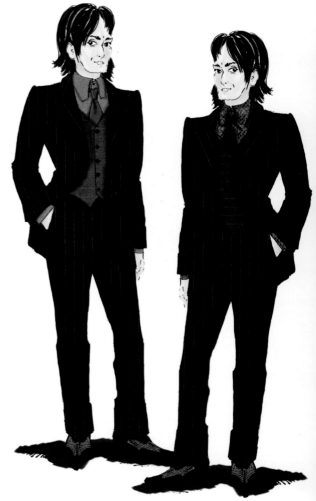

following Temime's approach that this was a way for the students to express their personalities, she dressed the twins in similar shirts and sweaters, but in complementary colors.

For *Harry Potter and the Half-Blood Prince*, as the twins have now created their own business, Weasleys' Wizard Wheezes, Temime saw them as establishing their own "brand." Their three-piece suits still match, but their shirts and shoes contrast, as well as their light-up ties. The suits were made by a London tailor, who was asked to provide a special pocket in the suit. "There's a little secret compartment inside the waistcoat," explains Oliver, "that holds a battery, which is how we control the flashing tie." Overall, Temime wanted them to be chic. "They have their own shop, so they have money, so they can be stylish. In their own way, of course, but stylish."

In *Harry Potter and the Deathly Hallows – Part 1*, George Weasley loses an ear during the transfer of Harry to The Burrow, and so Oliver Phelps needed to have a life cast done of his head. "The only time I've felt claustrophobic," he admits. "We thought that it would be, like, six blue dots around his ear," says James, "and the rest would be done by the computer, but it wasn't." Three prosthetic pieces were created for the effect, underneath a bandage and a wig that Oliver wore. At one point, he and director David Yates came up with the idea that "Maybe George had put a cartoonish-type ear on, and we had a competition for ideas, which Rupert won. We didn't do it, but I think maybe George didn't want to fix it, for the jokes. He did get to stick a toothbrush in the ear." "Well," teases James, "there isn't much brain there to keep the thing from falling out."

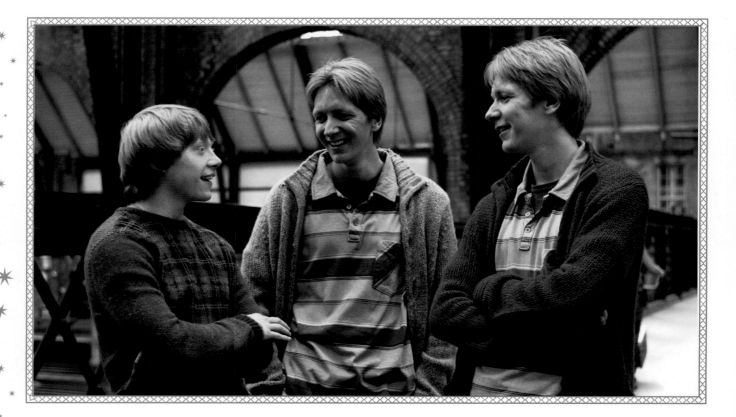

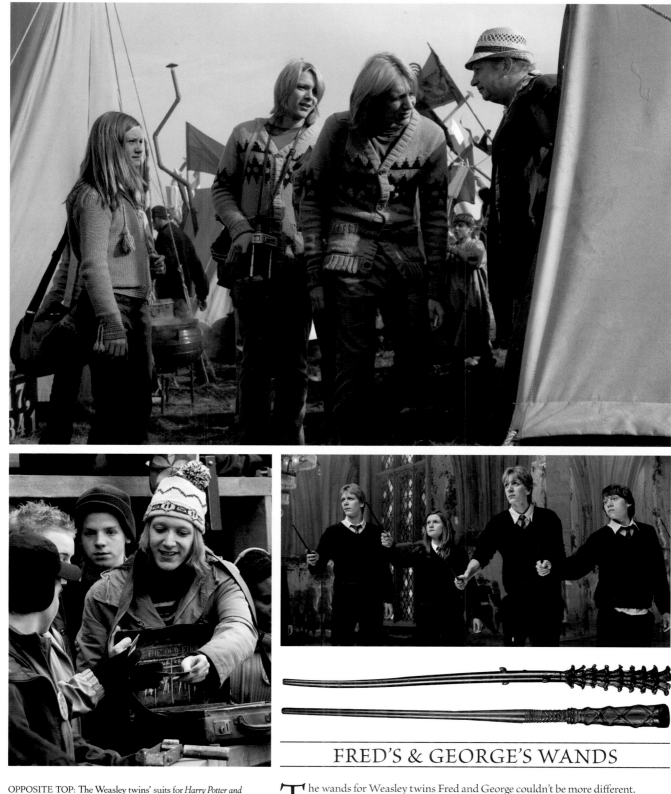

OPPOSITE TOP: The Weasley twins' suits for *Harry Potter and the Half-Blood Prince* as designed by Jany Temime, illustration by Mauricio Carneiro; OPPOSITE BOTTOM: Rupert Grint and his movie brothers Oliver and James Phelps share a laugh at King's Cross station behind the scenes on *Harry Potter and the Order of the Phoenix*; TOP: The Weasleys enter their tent at the 422nd Quidditch World Cup; ABOVE: Taking a bet on the first task of the Triwizard Tournament in *Harry Potter and the Goblet of Fire*, Fred wears a Molly-knitted cap and sweater; RIGHT: Dumbledore's Army practices in a scene from *Harry Potter and the Order of the Phoenix*.

FRED'S & GEORGE'S WANDS

The wands for Weasley twins Fred and George couldn't be more different. George's wand resembles a broomstick. "The *newest* style broomstick," says Oliver Phelps (George). "It's woven around at the end, and there's even a kind of saddle on it." "Mine has more like a pine cone at the end," says James Phelps (Fred). Several versions of each wand were made for different uses. "I know I had three," says James. "One that was like a hard rubber, and the other two were wood. I know they were wood because I broke both of them." "Not while shooting any action," Oliver adds. "It was on a photo shoot!"

Ginny Weasley

When asked if she would ever dress like her character, Ginny Weasley, actress Bonnie Wright smiles. "I think there are some quite unusual and different outfits that she has, but I don't think I would particularly wear the clothes that she wears. That's probably kind of helpful for me, because when I put them on it's a contrast to what I usually wear. It's a step to becoming the character."

"Of course there is a lot of knitting and crochet in Ginny's wardrobes," say Jany Temime. "For a long time, you could see that the mother was making clothes for the daughter. But for *Harry Potter and the Goblet of Fire*, we thought, no more. Ginny has decided to buy her own clothes. We wanted Ginny to change." Bonnie Wright agreed with the change. "Obviously, as she becomes older and more outgoing and confident in herself, she probably tries to tear away from the Weasley look. She does become less orange and less woolly." As Ginny matured, Temime dressed her in a different palette than her brothers, tending toward pinks instead of oranges, and used greens and browns that were dark and muted. Girlish jewelry and hair accessories disappeared. "Her wardrobe needed to reflect the delicate balance of a growing girl," explains Temime.

Bonnie Wright agrees that for Ginny's growing relationship with Harry, they needed her look to develop. "Because she was raised with all these older brothers, she's never really been a 'girly' girl. But at the Christmas party in *Harry Potter and the Half-Blood Prince*, you can see she's growing up, becoming a young woman. And it's obvious that Harry is seeing her in a different way, he's realizing his interest in her. So I think she's got to do something for him to recognize his new feelings."

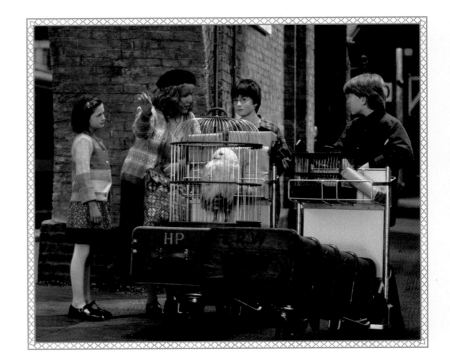

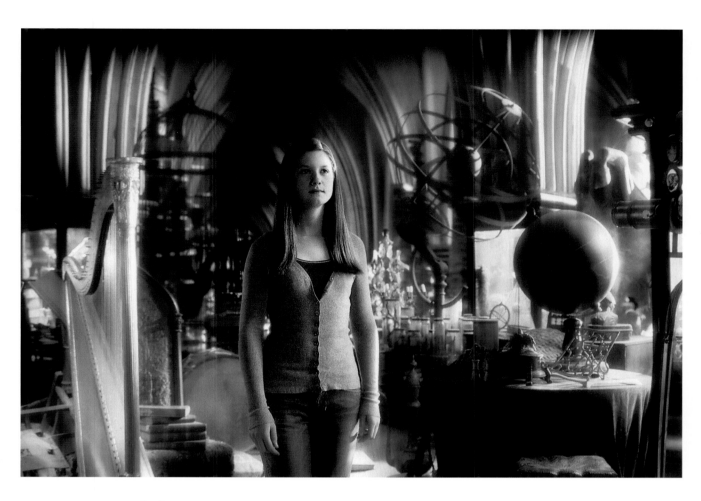

FIRST APPEARANCE:
Harry Potter and the Sorcerer's Stone

ADDITIONAL APPEARANCES:
Harry Potter and the Chamber of Secrets
Harry Potter and the Prisoner of Azkaban
Harry Potter and the Goblet of Fire
Harry Potter and the Order of the Phoenix
Harry Potter and the Half-Blood Prince
Harry Potter and the Deathly Hallows – Part 1
Harry Potter and the Deathly Hallows – Part 2

HOUSE:
Gryffindor

OCCUPATION:
Hogwarts Student, Gryffindor Chaser

MEMBER OF:
Dumbledore's Army

PATRONUS:
Horse

OPPOSITE INSET: Bonnie Wright as Ginny Weasley; OPPOSITE FAR LEFT: Wright sports a muted color palette in a publicity photo for *Harry Potter and the Half-Blood Prince*; OPPOSITE BOTTOM: Harry Potter asks the Weasleys for directions to Platform 9 ¾ in *Harry Potter and the Sorcerer's Stone*; ABOVE: Ginny before her first kiss with Harry in the Room of Requirement in *Half-Blood Prince*; LEFT: Bonnie Wright poses in her Hogwarts robes in a publicity photo for *Harry Potter and the Chamber of Secrets*.

GINNY'S WAND

Ginny Weasley's all-black wand features a swirl on the handle and a short studded section that creates a transition from the handle to the shaft. While filming *Order of the Phoenix*, Bonnie Wright noted a clear difference in the wand styles displayed by the actors during the battle in the Ministry. "Obviously, everyone holds their pen differently," she explains, "so it's kind of the same in the way you hold your wand. And when we chose our wands, before filming *Prisoner of Azkaban*, I think it was based on which one felt right in our character's hands as much as for the look."

"He's covered in blood again. Why is it he's always covered in blood?"

GINNY WEASLEY,
Harry Potter and the Half-Blood Prince

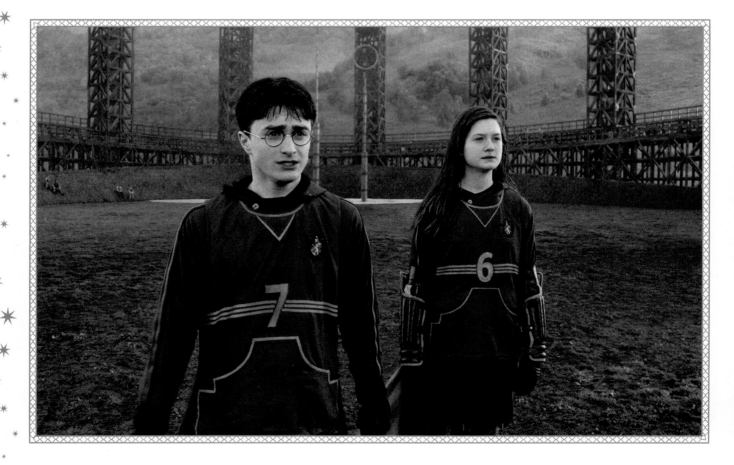

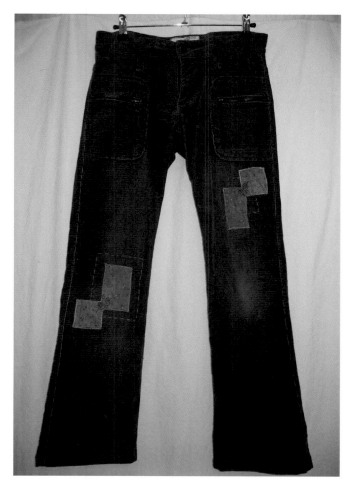

OPPOSITE INSET: Ginny Weasley practices her spells in *Harry Potter and the Order of the Phoenix;* OPPOSITE TOP: Bonnie Wright wears a rosier version of the Weasley palette in a publicity photo from *Harry Potter and the Goblet of Fire;* OPPOSITE BOTTOM: Harry Potter and Ginny in the new Quidditch practice wear for tryouts in *Harry Potter and the Half-Blood Prince;* TOP AND ABOVE: Homemade with love—a knitted hair tie and patched pants worn in *Half-Blood Prince.*

NON-WIZARD WEAR

After Harry Potter and the Prisoner of Azkaban, the students frequently began to dress in contemporary clothing. Brand logos were still not allowed, and Jany Temime considered the characters' proximities to current trends. "Harry and Hermione are more aware of fashion in the Muggle world," she explains, "while Ginny and Ron are not, and their choice of clothes would reflect that, as well as the influence of their own wizardy culture." To her, the challenge was to "keep them in character, dress them in a cool, modern way, and still have something magical about it." Ginny and the other kids' "Muggle" clothes were purchased at London shops, but typically changed. "Whatever we buy, it's new and it has to look like it's been worn, so we have to create that." At least thirty percent of these clothes were purchased, always in multiples, and then customized with added embellishments and alterations to sleeves and collars, and with different buttons and fastenings.

TOP AND ABOVE: While their clothes might have come from "Muggle" stores, Jany Temime's ensembles still broadcast "We're Weasleys" for Ginny in *Harry Potter and the Order of the Phoenix* and Ron and Ginny in *Harry Potter and the Goblet of Fire.*

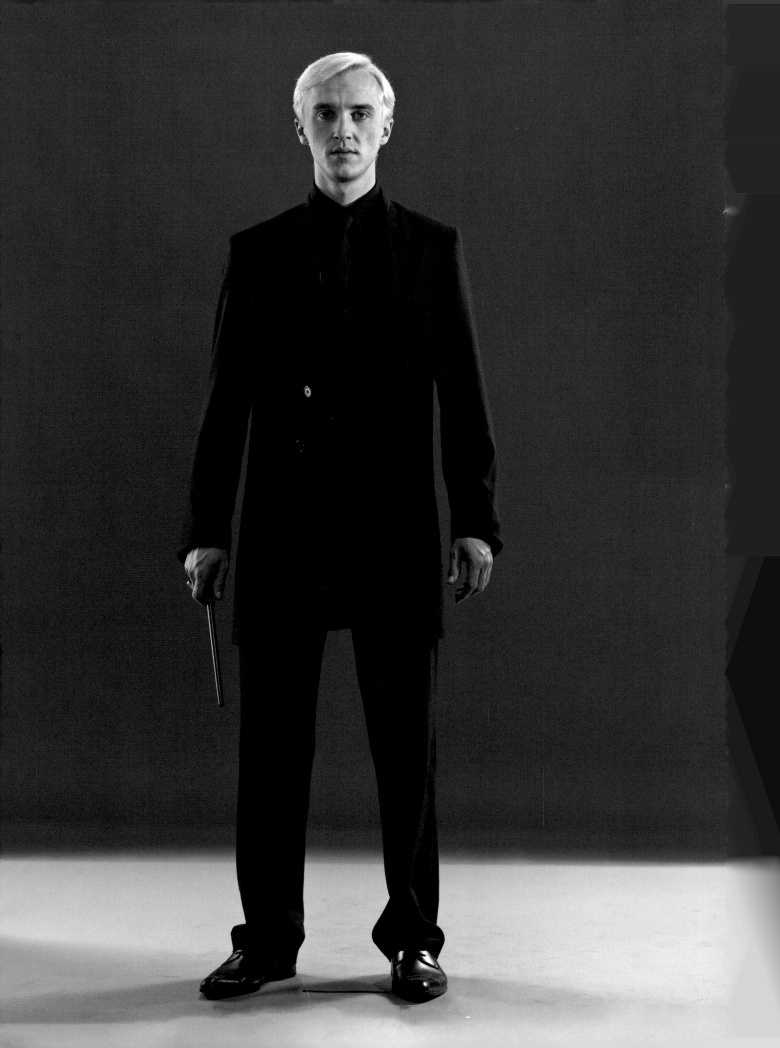

Draco Malfoy

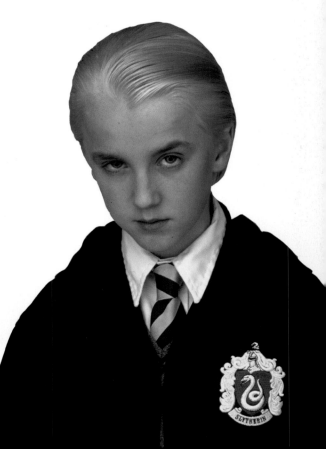

uring his audition for *Harry Potter and the Sorcerer's Stone*, actor Tom Felton knew he shouldn't reveal that he wasn't particularly familiar with the Harry Potter books. "One of the first things they asked at the audition was, 'What is your favorite scene in *Sorcerer's Stone*?' I was in a row of about seven actors, and the guy next to me said, 'Oh, Gringotts, I love the trolls.' When I was asked, I just said the same thing as him. 'I love the trolls, they're brilliant.' And I think Chris Columbus saw through that straightaway." Felton initially auditioned for the parts of Harry and Ron ("and Hermione!" he quips) before he was cast as the hero's silver-haired enemy.

For the look of Draco Malfoy, son of a very rich pureblood wizard family, Judianna Makovsky felt that it would be more effective to keep things simple and not let Draco's evilness be eclipsed by his clothing. One part of his look that did stand out was his white-blond hair. "My hair was obviously slicked back in the early years; they used a *lot* of hair gel," Felton recalls. As the films continued, the haircut became more natural, but for *Harry Potter and the Goblet of Fire*, "I wore a wig," Felton admits, "because I was getting tired of dyeing my hair blond every week, and they allowed me to do this. But I realized it looked better when it was blond for real, and that dyeing it wasn't so much of a problem for me when the result was worth it."

FIRST APPEARANCE:
Harry Potter and the Sorcerer's Stone

ADDITIONAL APPEARANCES:
Harry Potter and the Chamber of Secrets
Harry Potter and the Prisoner of Azkaban
Harry Potter and the Goblet of Fire
Harry Potter and the Order of the Phoenix
Harry Potter and the Half-Blood Prince
Harry Potter and the Deathly Hallows – Part 1
Harry Potter and the Deathly Hallows – Part 2

HOUSE:
Slytherin

OCCUPATION:
Hogwarts Student, Slytherin Seeker

MEMBER OF:
The Inquisitorial Squad,
Death Eaters

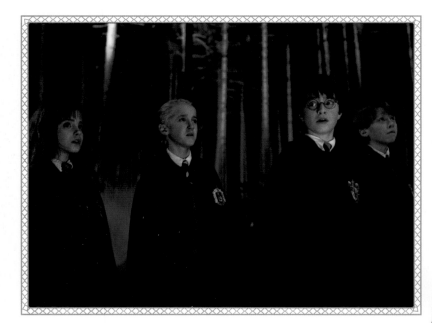

INSET: Tom Felton as Draco Malfoy; RIGHT AND OPPOSITE: Tom Felton in publicity photos for *Harry Potter and the Sorcerer's Stone* and *Harry Potter and the Half-Blood Prince*; ABOVE: Detention in the Forbidden Forest.

"My father will hear about this!"

DRACO MALFOY,
Harry Potter and the Goblet of Fire

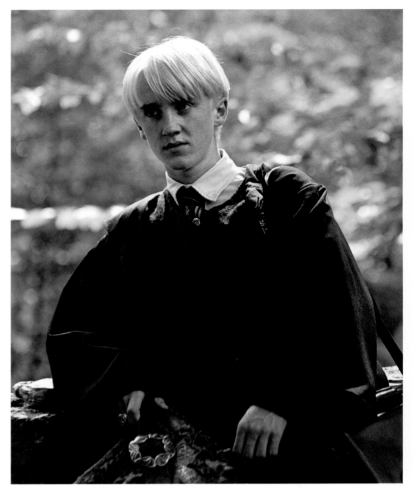

There were several occasions for Malfoy to show off his family's wealth—in *Harry Potter and the Prisoner of Azkaban*, during the trip to Hogsmeade, his clothes included a fur hat and designer coat that contrasted sharply with Ron's and Hermione's plain homemade wear, and his tuxedo robes in *Harry Potter and the Goblet of Fire* were top of the line. But it is in *Harry Potter and the Half-Blood Prince* that Draco became a true fashion plate. "Draco has made the decision to follow his father with the goal of becoming a Death Eater," Jany Temime explains. "He's dressed in a tailored black suit more often than his school robes, because we wanted to show that he thinks of himself as already being on his way out of school. That he is consciously separating himself from being a student." Through the course of the films, Tom Felton often received fan mail asking for him to put a different color into his wardrobe, but teases that, knowing his character, "There's no occasion where black doesn't fit in as far as Draco's concerned."

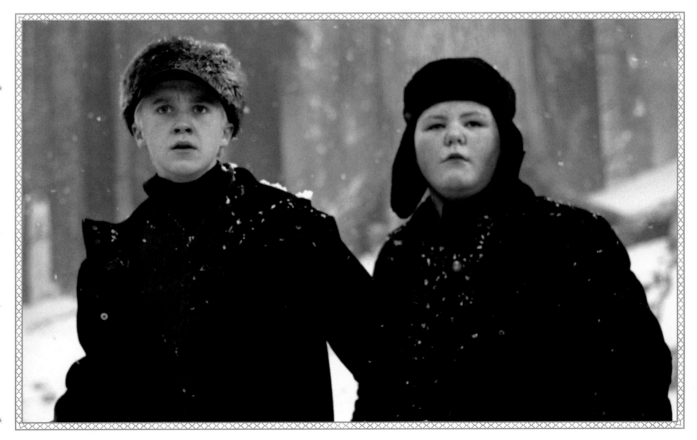

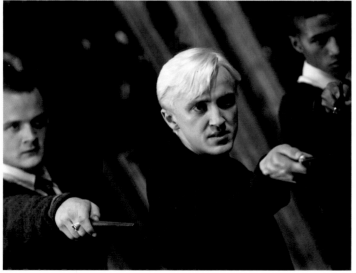

OPPOSITE TOP: Draco Malfoy awaits the Care of Magical Creatures class in *Harry Potter and the Prisoner of Azkaban* carrying his textbook and a personalized leather book bag; OPPOSITE BOTTOM: On a Hogsmeade visit, accompanied by Crabbe (Jamie Waylett), Draco keeps warm in a fur hat and leather gloves in *Prisoner of Azkaban*; TOP: Draco works on the Vanishing Cabinet in *Harry Potter and the Half-Blood Prince*; ABOVE: Slytherins Gregory Goyle (Josh Herdman) and Blaise Zabini (Louis Cordice) flank Draco during a fiery confrontation in *Harry Potter and the Deathly Hallows – Part 2*.

DRACO'S WAND

The simple design of Draco Malfoy's blunt-tipped wand was crafted from a light brown Mexican rosewood attached to a jet-black ebony handle. Draco was also briefly the master of Dumbledore's wand, after *Half-Blood Prince*, but he then lost his own wand to Harry Potter in *Deathly Hallows – Part 1*. Tom Felton is one of many actors who would choose his wand to take home as a souvenir of his time on the Harry Potter films. "Warwick Davis [Professor Flitwick] and I had a conversation about this one day," Felton recalls. "We asked, if we could take an item or two, what would we take? Both our first thoughts were our wands."

Luna Lovegood

Luna Lovegood might be considered "different" in comparison to her classmates at Hogwarts, but Jany Temime wanted to make sure that Luna did not appear freakish. "She may dress a bit more 'wizardy' than the other girls, but it's in Luna's personality to do that. She is clearly a girl with her own tastes and her own hobbies, which include making her own jewelry." Actress Evanna Lynch's knowledge of the character was a valuable resource to the designer. When Temime made a pair of red radish-shaped beaded earrings for her, Lynch insisted that the color was supposed to be orange (and they were actually Dirigible Plums). "She was very specific about a few things that were from her character," recalls Temime. "There was the Butterbeer-cap necklace, and shoes with strawberries on them. In fact, we put strawberries everywhere throughout her clothes because she liked strawberries." Lynch herself made the beaded hare ring that Luna wears to Professor Slughorn's Christmas party in *Harry Potter and the Half-Blood Prince*, as well as designing the lion hat she wears as a supporter of the Gryffindor Quidditch team.

Luna's mismatched outfits were colored dominantly in purples and blues, and the fabrics often featured animals or natural elements that added to their folk art feel. Jany Temime always considered that Luna lived in "her own

INSET: Evanna Lynch as Luna Lovegood; RIGHT: Lynch poses in a costume reference photo for *Harry Potter and the Order of the Phoenix*; BELOW AND OPPOSITE LEFT: Costume sketches showcase the uniqueness of Luna's wardrobe in designs by Jany Temime, sketches by Mauricio Carneiro; OPPOSITE RIGHT: Luna's Gryffindor-supporting hat as envisioned by Adam Brockbank for *Harry Potter and the Half-Blood Prince*.

FIRST APPEARANCE:
Harry Potter and the Order of the Phoenix

ADDITIONAL APPEARANCES:
Harry Potter and the Half-Blood Prince
Harry Potter and the Deathly Hallows – Part 1
Harry Potter and the Deathly Hallows – Part 2

HOUSE:
Ravenclaw

OCCUPATION:
Hogwarts Student

MEMBER OF:
Dumbledore's Army

PATRONUS:
Hare

"You're just as sane as I am."

LUNA LOVEGOOD,
Harry Potter and the Order of the Phoenix

homemade world. You felt she was a kid who collected insects or animals. She has an approach to the world that nobody else has. And I always wanted to reflect that in her clothing. I think it mattered."

Harry Potter producer David Heyman and director David Yates both have said of the actress, "Evanna *is* Luna." Lynch agrees, having felt an immediate connection to the character when she read *Harry Potter and the Order of the Phoenix*. One significant difference, Lynch will point out, is that she is probably more determined than Luna. Lynch waited in line for four hours as one of fifteen thousand young women to audition for the part in open casting calls that took place across the United Kingdom.

LUNA'S WAND

Like Ron Weasley, Luna Lovegood had two wands. Her first wand was a baton-style, with a vine featuring acorns that spiraled around it. For the scene where Luna first learns to cast a Patronus charm, in *Harry Potter and the Order of the Phoenix*, "I was a bit disappointed," actress Evanna Lynch recalls. "I said *Expecto Patronum* and not a thing came out of my wand, you know." This wand was confiscated by Death Eaters in *Harry Potter and the Deathly Hallows – Part 1*. During their imprisonment, it's reasoned, Ollivander fashioned her a new wand of a darker wood, with a long tulip-like flower as the handle.

Dean Thomas

ryffindor Dean Thomas lived with his Muggle mum before attending Hogwarts, and "lived an enjoyable version of a childhood at school," says Alfred Enoch, who plays Dean, "not like the Harry Potter nightmare experience." While developing his character, Alfred gave thought to what someone who grew up as a fan of the Muggle West Ham United football team (apparent in the decorations around Dean's dresser in the Gryffindor dorm) would think about Quidditch. "Can you imagine spending your life watching football and then there's basically this better version where people fly around on brooms and three things are going on at once? It's like, 'Wow.' I always liked him very much for that."

Alfred Enoch grew up with an actor father and had performed in several youth theater productions when casting directors for *Harry Potter and the Sorcerer's Stone* held auditions at his school. "Pretty much everyone auditioned," Alfred remembers, but he was not among them. "I thought, 'This is unrealistic, it's not going to happen,' and probably beneath that was some kind of fear that I knew already it was what I wanted to do. So, I didn't want to be told I wasn't good enough." One of the casting directors knew who he was—they had seen him in a stage production—and asked him to audition.

In *Harry Potter and the Order of the Phoenix*, Enoch felt Dean was put in a difficult position between his Gryffindor dormmates. "I saw him as quite close to Harry, but, of course he's best friends with Seamus," says Alfred. "And Seamus has a problem [with Harry], because his mum says Voldemort can't really be back, so, Seamus doesn't believe. Seamus is very distrusting of Harry; he's very negative at first." Dean joins Dumbledore's Army, but Seamus is conspicuously absent. "Dean wants to try to find a way to mediate this. This is a serious situation, and he's got to approach it like that." Seamus does eventually come around and join Dumbledore's Army, and Alfred knows that Dean had a big part in this. "He gets Seamus to go along to a meeting, and eventually Seamus gets incorporated."

To Alfred, Dean was a pretty ordinary guy who had a good sense of humor and great loyalty to his friends. "I always thought, he'll be all right," he adds. "He had it together. I think he's cool and popular, and he went out with Ginny!"

FIRST APPEARANCE:
Harry Potter and the Sorcerer's Stone

ADDITIONAL APPEARANCES:
Harry Potter and the Chamber of Secrets
Harry Potter and the Prisoner of Azkaban
Harry Potter and the Goblet of Fire
Harry Potter and the Order of the Phoenix
Harry Potter and the Half-Blood Prince
Harry Potter and the Deathly Hallows – Part 2

HOUSE:
Gryffindor

OCCUPATION:
Hogwarts Student, Gryffindor Chaser (temporarily)

MEMBER OF:
Dumbledore's Army

DEAN'S WAND

ean Thomas's wand is reminiscent of a baton, with a smooth shaft rendered in a dark brown hardwood. At the pommel, a knotty knob of wood has sent out a spiral of tendrils that wrap around its handle.

INSET: Alfred Enoch as Dean Thomas; ABOVE: Dean watches in the crowd at the second task of the Triwizard Tournament in *Harry Potter and the Goblet of Fire*; OPPOSITE INSET: Devon Murray as Seamus Finnigan; OPPOSITE RIGHT: Seamus creates an explosion while attempting the Levitation Charm.

Seamus Finnigan

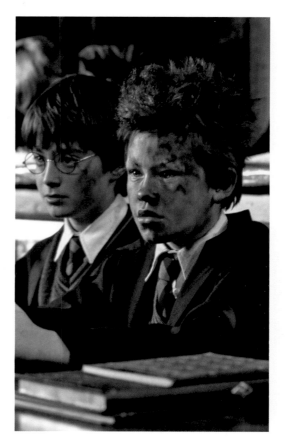

Actor Devon Murray feels the reason he might have gotten cast as Gryffindor Seamus Finnigan is because he didn't know anything about Harry Potter at the time. "I was really dyslexic when I was a kid, so I'd never read the books," he explains. "I didn't know anything about the story; who Harry was or what the franchise was even about." When a casting director asked Devon and another Irish actor to fly to England to audition, Devon went in for his screen test, walked past Daniel Radcliffe, and went up to director Chris Columbus. "I said, 'Hi Harry, nice to meet you!' They were looking for a stupid Irish guy, and I think I proved that day that I was their man."

One of his fondest memories of working on the Harry Potter films was his thirteenth birthday, which happened to be the day that the *Wingardium Leviosa* Charm was taught in Professor Flitwick's class. Seamus's efforts end in the feather blowing up (the first of many magical explosions he causes). "As soon as we finished filming, [producer] David Heyman brought in the biggest chocolate cake I'd ever seen in my life." There was *another* birthday celebration during lunch hour, and another at the end of the day's filming. "It was the first Harry Potter birthday, it was great fun, and I got to keep the feather I blew up."

Pranks were frequent and funny on the Harry Potter set, and one day on the film shoot for *Harry Potter and the Chamber of Secrets*, Robbie Coltrane (Hagrid) covered Devon's face in Band-Aids. When the young actor went to the hair and makeup trailer, the team was stunned. "Oh my God, Devon, what happened? What happened?" he remembers them saying. Devon told them he had been in a fight. Then they called down to Chris [Columbus]. "Oh, Chris, Devon has a lot of cuts all over his face, what do we do? We can't put makeup on it?" Finally, the hoax was revealed. "They weren't very happy, but they got a laugh in the end."

In *Harry Potter and the Prisoner of Azkaban*, the Gryffindor boys indulge in some fun magical sweets that cause them to make animal noises. Ron roars like a lion, Neville trumpets like an elephant, and Seamus . . . clucks like a chicken? "I was *meant* to be a chicken," says Devon. "So, I was going 'Bawk, bawk, bawk, bawk.' But in the movie, it was a monkey. I'm there bawking, but they had monkey noises coming out." The production had decided to change the choice of animal in postproduction, to Devon's surprise when he first saw the movie.

SEAMUS'S WAND

Seamus Finnigan's wand has a style similar to Dean Thomas's: It's a baton style, this time crafted in a mottled light brown wood. A black band spirals down from the pommel to around the handle. Devon Murray broke the most wands during the ten years of filming Harry Potter, and while few actors were allowed to keep their wands after the movies wrapped, Devon was able to keep half of one of his.

FIRST APPEARANCE:
Harry Potter and the Sorcerer's Stone

ADDITIONAL APPEARANCES:
Harry Potter and the Chamber of Secrets
Harry Potter and the Prisoner of Azkaban
Harry Potter and the Goblet of Fire
Harry Potter and the Order of the Phoenix
Harry Potter and the Half-Blood Prince
Harry Potter and the Deathly Hallows – Part 2

HOUSE:
Gryffindor

OCCUPATION:
Hogwarts Student

MEMBER OF:
Dumbledore's Army (eventually)

Lavender Brown

Actress Jessie Cave knew she was "perfect" for the part of Lavender Brown, who falls hard for Ron Weasley in *Harry Potter and the Half-Blood Prince*. "I had just finished reading the book, so it was really uncanny when I was called to audition," she remembers. "And I immediately thought, 'Oh, my God, yeah, I'm perfect.'" Jessie hadn't actually liked the character of Lavender when she read *Half-Blood Prince*. "She was annoying and everything, but I thought she'd be such a fun character to play. I was there at the right time, right person—I was lucky. But I loved playing Lavender Brown. She's brilliant."

Jessie also loved working with actor Rupert Grint. "He's such a nice guy, and I think he's got a really good kind of comic timing, so it was really fun to bounce off that." Lavender is quite physical and affectionate, "and even kind of cheesy, so it was really funny." Unfortunately, both Rupert and Jessie had a bad habit of "corpsing"—breaking out into giggles while filming a scene. "Together we were really bad," she admits. "I just found everything so funny, and I went a bit too far with some things, though they actually worked and ended up in the film, which is bizarre. But he was a really great person to act with."

Costume designer Jany Temime thought Lavender was a great character to dress. "Lavender is beautiful and full of life," says Temime. "Very flirty and very, very funny." Temime dressed her in romantic colors, so that her exterior could mirror her heart-led interior. "She is in love with being in love. She is lovely and coquettish. So, I wanted her to be very girly and wear lots of pretty colors and lots of patterns." Different from a majority of characters in the Harry Potter films, whether in robes or not, Lavender had a change of clothes for each of her appearances.

Jessie can point to what she calls two defining moments in her experience working on the Potter films. The first is when Lavender and Ron have a kissing scene on a staircase. "The actual staircase didn't have a wall to support it, which I didn't realize," she explains. "I didn't have my contacts in, and it was really high up. We were supposed to run up the staircase, laughing and joking." It was only later that she learned a stunt person was stationed at the bottom of the stairs in case either of them fell.

The other was on the set of *Harry Potter and the Deathly Hallows – Part 2*. "Lavender is not very lucky," she says. "She doesn't meet a nice ending; she gets eaten by Fenrir Greyback and dies." Lavender's death scene was shot after a very, very long day of filming; in fact, it was almost dawn when it came time to film it. "They had to do the close-up of my face, and this had been left until the last, last minute. There was hardly any time left before it became sunlight," she explains, "and I obviously wanted to do it well." David Yates and his crew finished setting up the shot as Jessie was contemplating this. "I was so cold and lying on the floor, and then basically it was, 'Action!' I just had to be dead, but with my eyes open, and I thought, 'Don't mess this up!' Then it was done. I survived, and I didn't blink, and I didn't laugh, or move, or anything." It was just the one shot and then the crew moved on. "That's film, really, it's the moment," she says. "It was quite intense, but it summed up my entire experience in a way. You had to be up to scratch, and that's brilliant."

FIRST APPEARANCE:
Harry Potter and the Half-Blood Prince

ADDITIONAL APPEARANCES:
Harry Potter and the Deathly Hallows – Part 2

HOUSE:
Gryffindor

OCCUPATION:
Hogwarts Student

LAVENDER'S WAND

Lavender Brown's wand appears to be the complete opposite of her personality. Whereas she is colorful and bubbly, her wand is a straight baton stick with a thin black circle above the pommel and a black curve painted around the top of the handle. The wand is divided into two sections made of different woods—a medium brown wood for the handle and a mahogany wood for the shaft.

Cho Chang

One day in Scotland, while Katie Leung's father was watching television, he saw an announcement about casting for the fourth Harry Potter movie, *Harry Potter and the Goblet of Fire.* "It said if you were sixteen and if you were Chinese and had a British passport, you should audition," she remembers. "My dad thought, 'Let's just give it a try.'" Flying down to London, Leung joined five thousand other young women who were trying out for the part. Leung had only seen the first two Harry Potter films and had no idea of Cho Chang's place in the story. "I didn't realize that Cho would be Harry's first crush when I went, so I didn't think it was such a big deal then. I did after I got the part!"

Harry asks Cho if she'll go to the Yule Ball with him but is flattened when he learns she already has a date—Cedric Diggory. If not for that, Katie thinks there's no doubt Cho would have gone with him. "I think she would've definitely said yes if she wasn't going with Cedric, because she likes him. But I guess first come, gets her," she says, smiling.

At the end of *Goblet of Fire*, Cedric is killed by Lord Voldemort. Katie admits that crying for the scene where Harry brings back Cedric's body was one of the hardest things she had to do in the film, but not for the reasons you'd think. Katie started crying as soon as Harry and Cedric returned, over the course of several takes. "But then I realized that the shot wasn't on me," she explains. After a few more takes, director Mike Newell "decided it was my turn. By that time, my tears were all dried up, and I had no more tears left!"

During the events of *Harry Potter and the Order of the Phoenix*, Cho signs up to be in Dumbledore's Army. "She wants to avenge Cedric's death," says Katie, "and she's determined to be taught all this magic." Being a member of Dumbledore's Army brings her closer to Harry in several ways, ending in a kiss between them right before Christmas.

"When she sees a photo of Cedric, she becomes really upset," says Katie. "Harry spots her and asks if she's all right. One thing leads to another, and before you know it, they're kissing," she says with a laugh. "That's what usually happens in your first kiss."

Katie admits that both she and Daniel were nervous about they're first on-screen kiss. "I wasn't expecting it to be romantic, because you've got the whole crew watching," she explains. "What helped her that day was director David Yates keeping the set to the minimal amount of people and dimming the lights. "Daniel also made it really easy for me," she remembers, "and he's a very good kisser."

FIRST APPEARANCE:
Harry Potter and the Goblet of Fire

ADDITIONAL APPEARANCES:
Harry Potter and the Order of the Phoenix
Harry Potter and the Half-Blood Prince
Harry Potter and the Deathly Hallows – Part 1
Harry Potter and the Deathly Hallows – Part 2

HOUSE:
Ravenclaw

OCCUPATION:
Hogwarts Student

MEMBER OF:
Dumbledore's Army

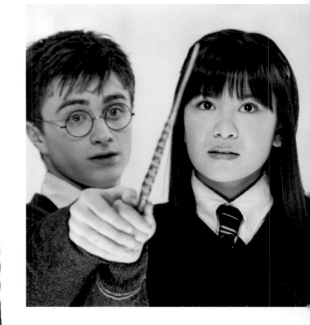

OPPOSITE INSET: Jessie Cave as Lavender Brown; OPPOSITE RIGHT: Lavender displays her affection for Ron in *Harry Potter and the Half-Blood Prince*; INSET: Katie Leung as Cho Chang; ABOVE: Harry helps Cho with a spell in the Room of Requirement.

CHO'S WAND

Cho Chang's wand is fashioned from a rich red wood, with a cinnabar-type color. The wand's design has three distinctive parts: The pommel and handle feature four or so twists that flow into a pattern of fossilized leaves on the first half of the shaft. The leaves then segue into an ever-diminishing spiral that ends at the tip.

Student Robes

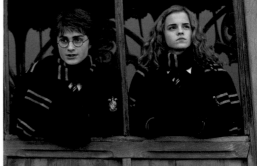

To *Harry Potter and the Sorcerer's Stone* costume designer Judianna Makovsky, students attending a "traditional English school," which Hogwarts is in its own way, meant creating a school uniform. "But J.K. Rowling said that the kids did not wear uniforms. In fact, it was considered more interesting to *not* have uniforms. It was rooted in the English school system, but it was also fantasy." Makovsky still felt strongly about a unified look. "So we tested Harry (Daniel Radcliffe) in modern clothes, and then tested him in the uniform." The filmmakers agreed with Makovsky that the uniforms worked better visually. And with costumes needed in multiple versions for the four hundred children playing Hogwarts students, "I have to say it saved our lives, because imagine trying to dress that many children in individual outfits!"

The first Hogwarts uniforms consisted of gray flannel trousers for the boys and gray flannel pleated skirts for the girls, white shirts for both. "Sometimes they wore a sweater vest, sometimes they had a sweater with their house colors on it, and each had a house tie." The first years started out with a black tie, but this was soon exchanged for one with the Hogwarts symbol on it. The students' robes were based on traditional academic gowns, "with a small twist of sorts to give them wizard sleeves." The robes were so comfortable that Daniel Radcliffe described them as feeling like pajamas, but admits that he got a bit hot wearing them in the Great Hall, which often had fires lit in the fireplaces. The students wore pointed hats that could fold up and be put in their pocket. Another pocket would hold their wand, although Makovsky admits that even she could never figure out how to put it in or take it out quickly.

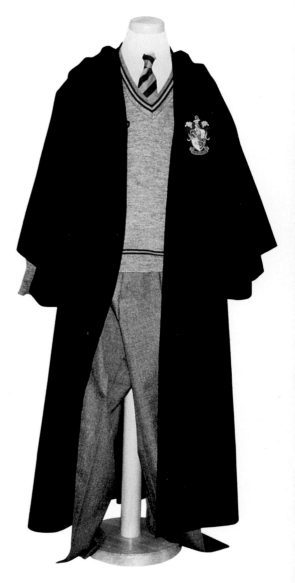

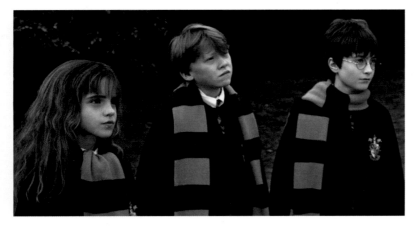

INSET: The Hogwarts crest; ABOVE: Hermione, Ron, and Harry in first years' robes and scarves in *Harry Potter and the Sorcerer's Stone*; RIGHT: Gryffindor robes for *Harry Potter and the Chamber of Secrets*; TOP: Harry and Hermione wearing the redesigned robes and scarves in *Harry Potter and the Goblet of Fire*; OPPOSITE TOP: Ties and crests for the four houses designed for *Sorcerer's Stone*; OPPOSITE BOTTOM LEFT: Costume reference for girl's uniform for *Sorcerer's Stone*; OPPOSITE BOTTOM RIGHT: Alfred Enoch (Dean Thomas) poses in scarf and robe for *Sorcerer's Stone*.

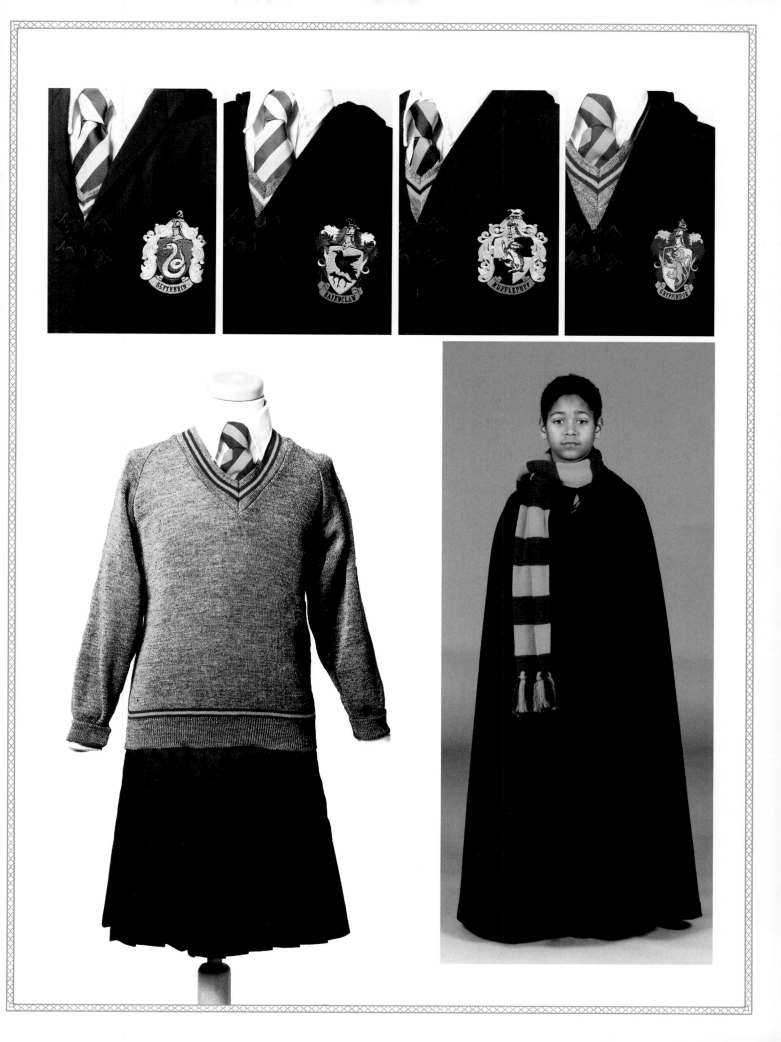

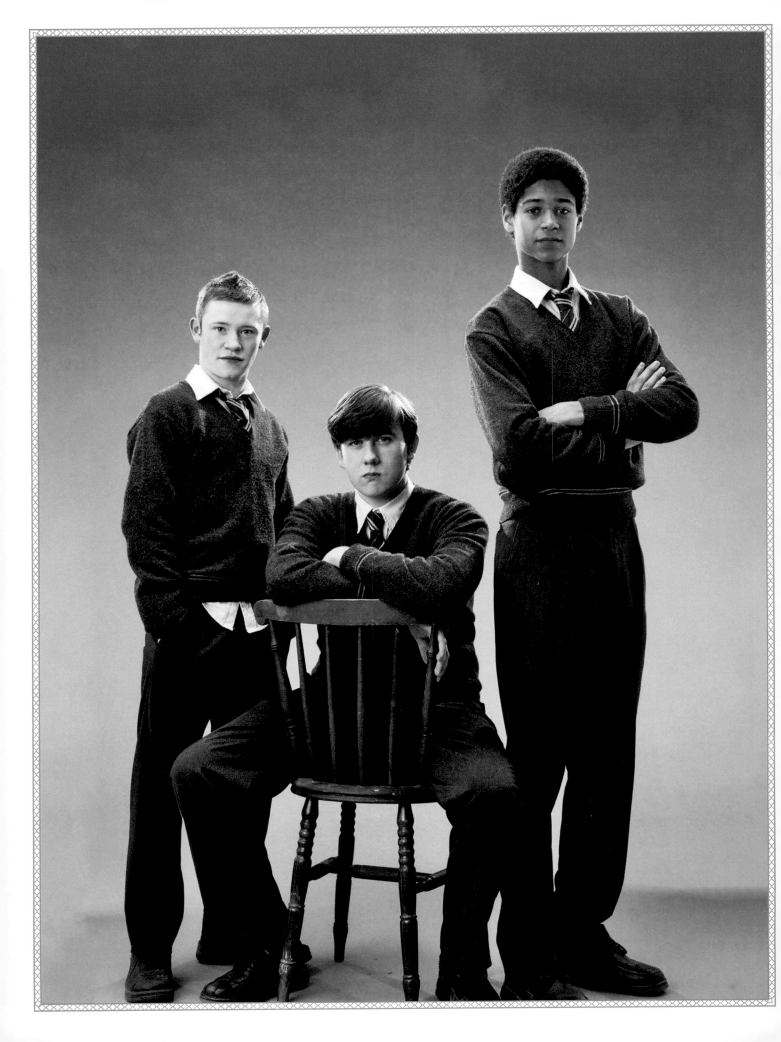

"You two'd better change into your robes. I expect we'll be arriving soon."

HERMIONE GRANGER,
Harry Potter and the Sorcerer's Stone

Jany Temime "changed the uniforms completely," she states, on *Harry Potter and the Prisoner of Azkaban.* The robes are fabricated out of wool, the shirts are 100 percent cotton, and the ties are now bigger and richer, made in a shiny silk. One of the most noticeable changes was that the pants, skirts, and sweaters are much darker, now black instead of the original gray. She placed the house colors in the lining of the robes, wanting to insure that each student's house could be seen clearly in their outfit, even across the Great Hall. The pointed hats were dropped and hoods were added, which Temime felt made the design "more urban. I wanted to make that link to the twenty-first century, as all kids have a hoodie." Another idea Temime had in concert with director Alfonso Cuarón was that, as the kids were getting older, "they would want to wear things their own way." She gave them the choice of interchangeable pieces, for example, a singlet or cardigan or oversized sweater, which would illustrate the personality of the child, and they were allowed to have shirts hanging out or loosened neckties (until Dolores Umbridge's tenure).

LEFT AND OPPOSITE: Jany Temime's new costume designs for the student robes included more black and less gray, as seen in sketches by Laurent Guinci, as well as in a publicity photo featuring Devon Murray (Seamus Finnigan), Matthew Lewis (Neville Longbottom), and Alfred Enoch (Dean Thomas) for *Harry Potter and the Order of the Phoenix;* ABOVE: Goyle and Draco Malfoy pull up their hoods—now attached to the robes—in *Harry Potter and the Prisoner of Azkaban.*

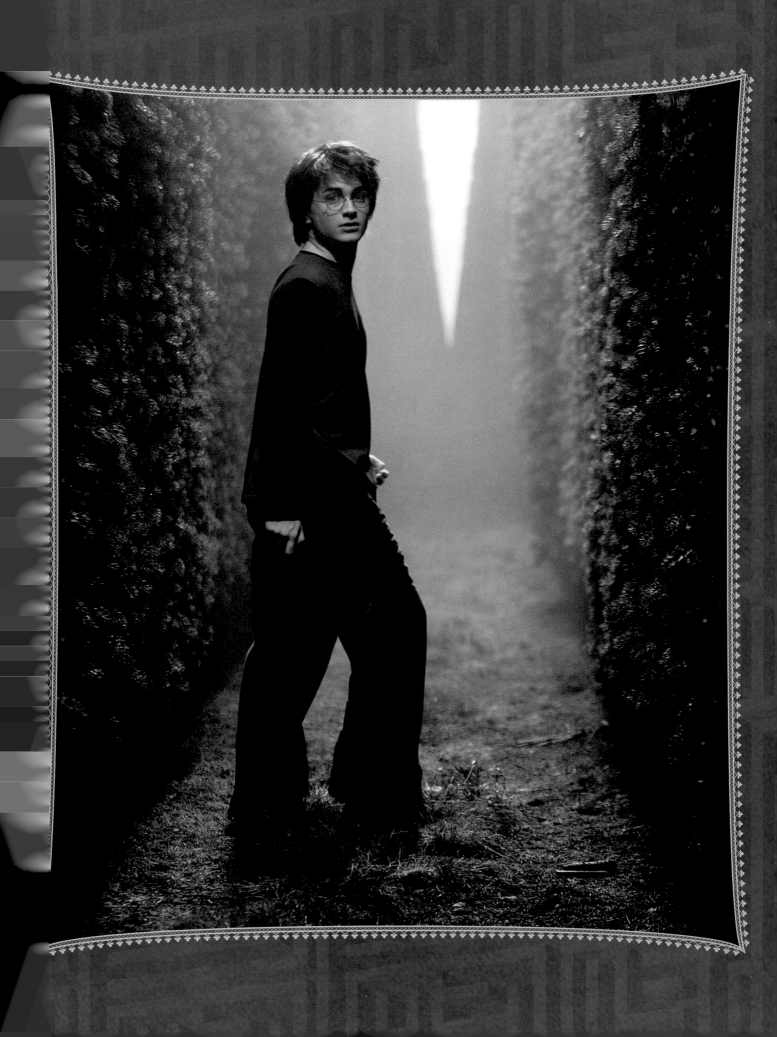

Chapter 2

The Triwizard Tournament

HOGWARTS
Harry Potter

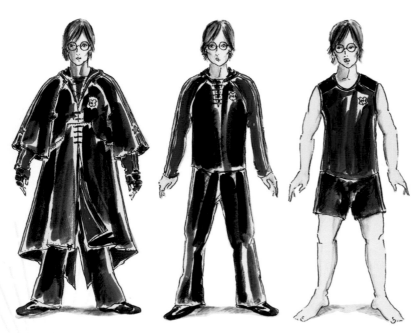

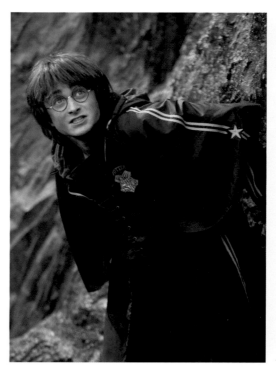

"What people don't realize," says Jany Temime, "is that there isn't just one costume for Harry—he has doubles and stunt doubles, and so you have multiples of the costume. We had five different stages of dragon costumes, from a clean version when he first enters, to a fully destroyed one at the end of the scene, so in total there were more than thirty-five dragon costumes just for Harry." A team of breakdown artists used sandpaper, lighters, and other tools to create the appearance of Harry's encounter with the fire-breathing Hungarian Horntail.

The makeup and hair departments were particularly challenged by the second task of the Triwizard Tournament. In addition to scars placed on Daniel Radcliffe's shoulders that came from Harry's combat with the dragon in the first task, the diving mask the actor wore between scenes in order to keep his eyes from becoming bloodshot underwater fitted exactly over the lightning bolt scar on his forehead. In order to keep the scar coming off to a minimum, Amanda Knight and her crew developed a more sturdy waterproof makeup. "It did come off a few times," recalls Knight, "so we had to get him out on a few occasions to get the scar back on. But whatever happened to him in the tank was out of our control. We'd just stand by the side there, twitching."

PAGE 54: Harry Potter in the maze for the third task of the Triwizard Tournament; INSET: Daniel Radcliffe in a publicity photo for *Harry Potter and the Goblet of Fire*; TOP LEFT, BELOW, AND OPPOSITE TOP: Jany Temime's designs for the three Triwizard Tournament tasks needed to accommodate broom-flying and swimming, sketches by Mauricio Carneiro; ABOVE: Harry in the dragon arena for the first task; OPPOSITE BOTTOM: Artwork by Dermot Power of the placement of special-effects gills that result from Harry's ingestion of Gillyweed for the second task.

Another challenge was for Nick Dudman's team to give Harry the webbed hands and feet that materialize after he ingests Gillyweed. The fins were created easily as a molded prosthetic attached to Radcliffe's feet, containing a semi-rigid interior and a soft, flexible exterior that dovetailed into his ankles. In post-production, his ankles and heels were removed digitally.

The webbed hands took a bit more experimentation. The first attempt was to attach webbed material between Radcliffe's fingers, but this came off when his hands powered through the water while swimming. The second try was to use a thin webbed glove, which stayed on but made the actor's hands look stubby. Length was added to the gloves, which made his hands look too big. The solution came when one of the crewmembers in the art finishing department was spotted washing a pair of nylon tights. "Her hand was stretched under the water, with the tights pulled up on her arm," Dudman explains. "But you couldn't actually see the tights on her hand." So a pair of tights was stretched over Radcliffe's hands and pulled up to under his tank top. Glue was applied between his fingers and the two layers of nylon were pressed together. "I think that was one of the cleverest theatrical tricks I've ever seen," says Dudman.

Radcliffe's costume for the task sported Gryffindor house's scarlet on the top when seen above the lake, but when under the waterline, another illusion came into play. Filming in fresh or saltwater changes the color of clothing; in this case, the red would be perceived as a dark brown, and so the top Radcliffe wore underwater was actually orange.

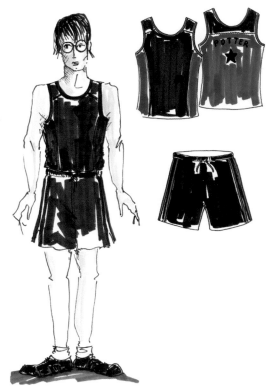

HOGWARTS
Cedric Diggory

"Cedric's a pretty nice guy," says actor Robert Pattinson, who plays the Hogwarts Triwizard Tournament champion in *Harry Potter and the Goblet of Fire*. "He plays fair. And he sticks to the rules, like he should." But, as Pattinson admits, "It's actually quite a lot of pressure playing the nice guy! And you know what they say about nice guys . . ." Director Mike Newell was particular about his casting of the part. "I knew that Cedric was going to die and I knew that in dying he would be very important to the story. I wanted him to be one of those clearly sacrificial figures, like the ultimate fighter pilot. And that's absolutely one of the things that Robert's got available. He's glorious-looking, and he does have that sort of posh doom about him."

For the champions' costumes for the Triwizard Tournament, Jany Temime chose synthetic fabrics that would be tough and durable during the three tasks, taking her cue from her redesign of the Quidditch uniforms for *Harry Potter and the Prisoner of Azkaban*. The design of the Hogwarts costumes was the same for both Harry and Cedric, just in their house's different colors. Multiple versions were required, though, as the various stunts took their toll on the outfits. The stunts during the three tasks were challenging for the actors, but Pattinson says that jumping out of the tree for his first appearance in the film "was a nightmare. It really takes it out on your knees after a while, jumping some twelve feet or so. The first one was quite fun. But after a while, my knees got very stiff very quickly. I think by the final take it really showed in my expression when I landed!"

FIRST APPEARANCE:
Harry Potter and the Goblet of Fire

HOUSE:
Hufflepuff

OCCUPATION:
Hogwarts Student, Triwizard Tournament Champion, Hufflepuff Seeker

CEDRIC'S WAND

Cedric Diggory's black-tipped baton-style wand is wrapped around with wheel-like designs and alchemical symbols etched at the handle.

INSET AND OPPOSITE: Robert Pattinson as Hufflepuff champion Cedric Diggory; RIGHT: Costume designs for Cedric's champion's wear by Jany Temime, sketches by Mauricio Carneiro for *Harry Potter and the Goblet of Fire*.

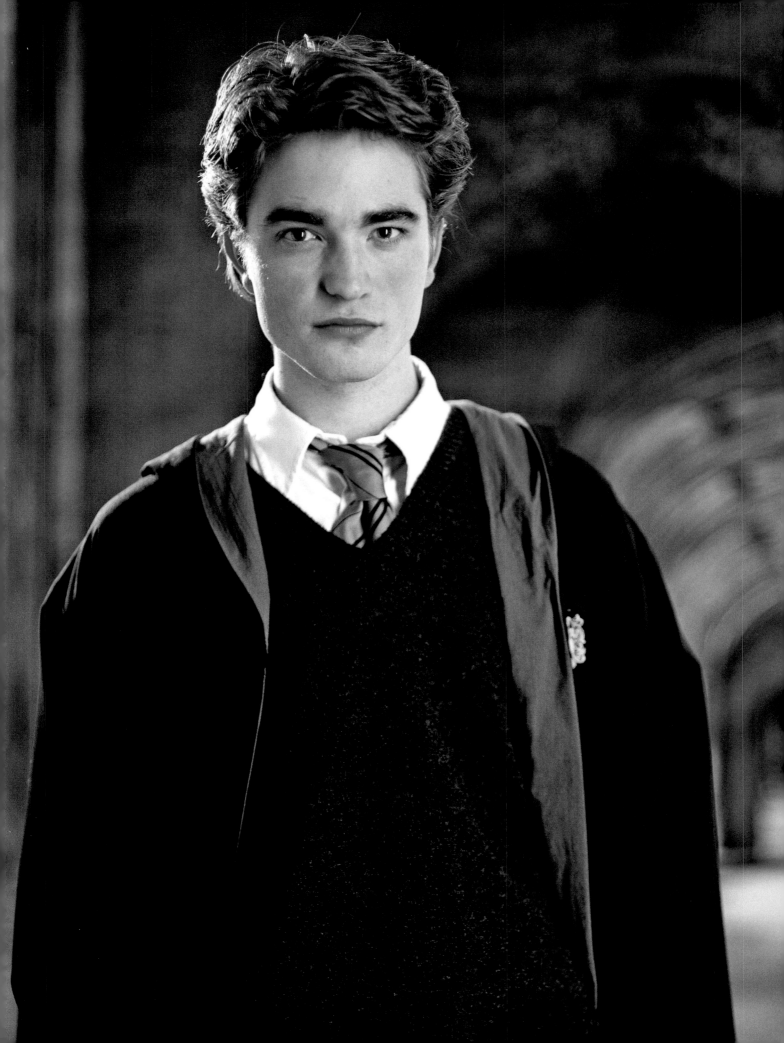

BEAUXBATONS
Fleur Delacour and the Beauxbatons Girls

FIRST APPEARANCE:
Harry Potter and the Goblet of Fire

ADDITIONAL APPEARANCES:
Harry Potter and the Deathly Hallows – Part 1
Harry Potter and the Deathly Hallows – Part 2

OCCUPATION:
Beauxbatons Student,
Triwizard Tournament Champion

Clémence Poésy, who plays Fleur Delacour, feels that the Beauxbatons girls made an impressive entrance into the Great Hall of Hogwarts in *Harry Potter and the Goblet of Fire*. "But I wanted to switch with the Durmstrang boys, at least once, and come in doing their stuff." Poésy was an avid fan of the Harry Potter novels and has strong opinions about the character she plays. "In a way, she's what the English think a French girl would be. She's chic, and graceful, and very serious, but she's also Miss Perfect. I saw her as the kind of girl I used to hate in high school!" she ends with a laugh. "She's not a cliché, but she embodies many French clichés."

Jany Temime attended a French boarding school when she was young and remembers, "It was very important that we were always wearing the same thing. And we were quite happy to do it, which I think is the big difference with English children, because when they have a uniform, the first thing they do is to try to find a way to change it." She brought another personal observation from being French

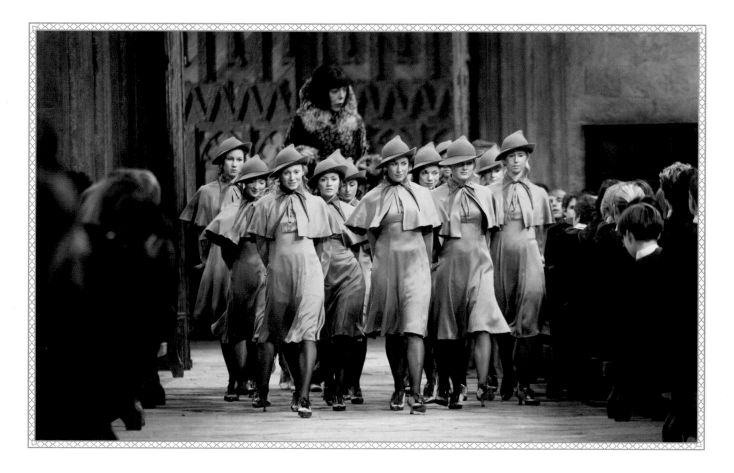

into the design of the costumes—that of the cold Scotland climate. "In Scotland they wear wool, and even if it's a beautiful wool it's still wool. It's practical and it keeps you warm. So then the French girls arrive wearing silk, completely unaware of the climate in Scotland, completely impractical, which I thought was great." For their outfits, Temime chose a fabric in what is known as "French blue," as it would stand out from the blacks, browns, and grays of the other students' muted palette. Pointed hats that resemble a wizardy version of a Trilby hat and a short cape complete an outfit with either a short dress or a short jacketed suit.

FLEUR'S WAND

Fleur Delacour's wand boasts an intricately carved design at the handle, and a long leaf that wraps itself around the shaft.

OPPOSITE INSET AND OPPOSITE RIGHT: Clémence Poésy as Beauxbatons champion Fleur Delacour; OPPOSITE TOP LEFT: Beauxbatons crest and Fleur's Triwizard Tournament outfits, sketches by Mauricio Carneiro; ABOVE: Madame Maxime follows her Beauxbatons charges into the Great Hall in *Harry Potter and the Goblet of Fire*; LEFT: Sketches by Mauricio Carneiro of Jany Temime's designs for Gabrielle Delacour (left and right) and the not-very-warm French blue Beauxbatons uniform (center).

DURMSTRANG
Viktor Krum and the Durmstrang Boys

Actor Stanislav Ianevski considers his casting in the role of Durmstrang champion (and "Bulgarian bon-bon") Viktor Krum "a Hollywood fairy tale. I was running down a hall at school and the casting director heard me shouting to someone and she asked me to audition." There is irony that the sound of Ianevski's voice led him in the direction of the role of a character he describes as "more of a physical being than a talkative one." Furthermore, Ianevski, who is originally from Bulgaria, had been living in England for several years and had lost any distinctive native inflections. "For the film, Viktor Krum really isn't good at English. So I do go back to a rough, tough Bulgarian accent."

Jany Temime provided a strong Slavic flavor to warm woolen clothing for the "sons of Durmstrang," a wizarding school set in a northern European clime. Unlike the Beauxbatons girls, the boys are dressed for winter in high-collared, fur-lined coats. The top of Karkaroff's staff and the coats' belt buckles feature the double-headed eagle that is the coat of arms for Durmstrang, while coat buttons resemble the talons of these raptor birds grasping the thick material. The students wear variations on the traditional Russian *ushanka* cap, with its round crown and earflaps, and the *shapka* hat, with its peaked top. Temime thought of Durmstrang in terms of a military-type school, and so the clothes are more utilitarian and, unlike the Hogwarts students, the boys were not given the option of individuality. Additionally, Eithne Fennel notes that, "The boys' hair was clipped every other day," to keep it consistently short. Ianevski credits the clothing for helping him shape his character. "I wear a very big and hot coat. But once I have it on I forget about the heat. I become more powerful and focused. As soon as I put that big coat on, I feel pimped out, as the Americans say."

FIRST APPEARANCE:
Harry Potter and the Goblet of Fire

ADDITIONAL APPEARANCE:
Harry Potter and the Deathly Hallows – Part 1
(deleted from film)

OCCUPATION:
Durmstrang Student, Triwizard Tournament
Champion, Bulgarian National
Quidditch Team Seeker

KRUM'S WAND

The eagle that serves as a symbol of the Durmstrang Institute is echoed in the kestrel bird's head sculpted on the handle of Viktor Krum's wand. The light wood, with a natural curve to it, is roughly carved.

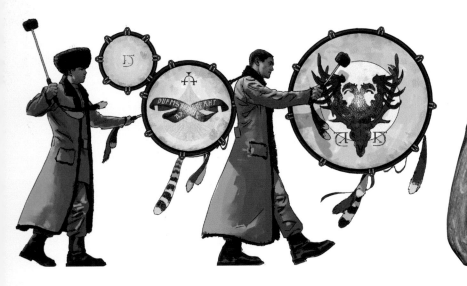

*"Mostly he watches me study.
It's a bit annoying actually."*

HERMIONE GRANGER,
Harry Potter and the Goblet of Fire

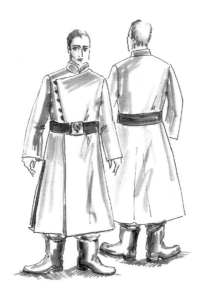

OPPOSITE INSET AND BELOW: Stanislav Ianevski as Durmstrang champion Viktor Krum; OPPOSITE RIGHT: Krum is flanked by Headmaster Karkaroff and his aide upon his entrance into the Great Hall in *Harry Potter and the Goblet of Fire*; OPPOSITE BOTTOM LEFT: Artwork by Adam Brockbank for *Goblet of Fire*; LEFT: Three different iterations of student coats—all very warm; BELOW LEFT: Viktor's Triwizard Tournament champion's wear was decorated with the double-headed eagle insignia of the school, all sketches by Mauricio Carneiro.

INSIGHT
EDITIONS

PO Box 3088
San Rafael, CA 94912
www.insighteditions.com

 Find us on Facebook: www.facebook.com/InsightEditions
 Follow us on Twitter: @insighteditions

Library of Congress Cataloging-in-Publication Data available.

ISBN: 978-1-68383-749-7

Publisher: Raoul Goff
Associate Publisher: Vanessa Lopez
Creative Director: Chrissy Kwasnik
Designer: Judy Wiatrek Trum
Editor: Greg Solano
Editorial Assistant: Jeric Llanes
Senior Production Editor: Rachel Anderson
Senior Production Manager: Greg Steffen

Written by Jody Revenson

REPLANTED PAPER

Insight Editions, in association with Roots of Peace, will plant two trees for each tree used in the manufacturing of this book. Roots of Peace is an internationally renowned humanitarian organization dedicated to eradicating land mines worldwide and converting war-torn lands into productive farms and wildlife habitats. Roots of Peace will plant two million fruit and nut trees in Afghanistan and provide farmers there with the skills and support necessary for sustainable land use.

Manufactured in China by Insight Editions

10 9 8 7 6 5 4 3 2 1